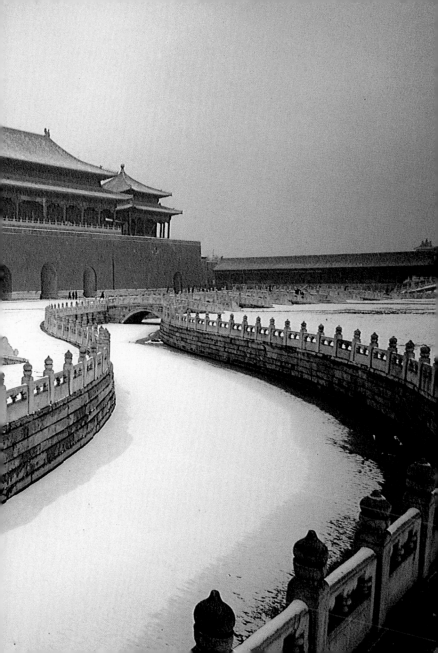

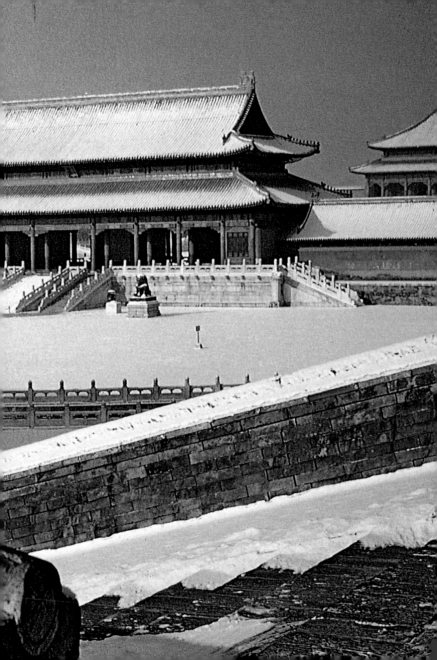

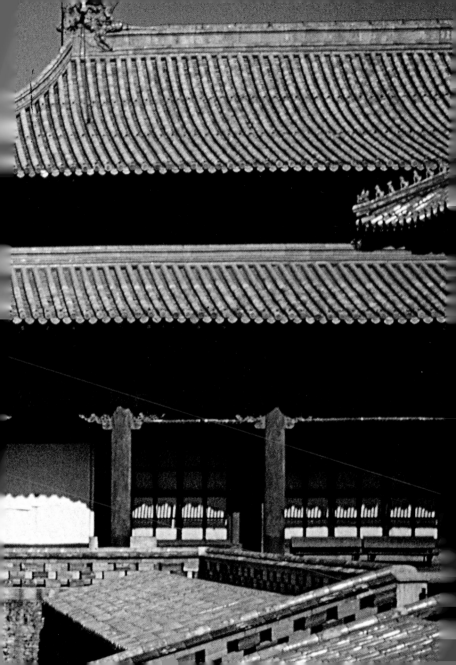

CONTENTS

THE FORBIDDEN CITY
CENTER OF IMPERIAL CHINA

Gilles Béguin and Dominique Morel

DISCOVERIES®
HARRY N. ABRAMS, INC., PUBLISHERS

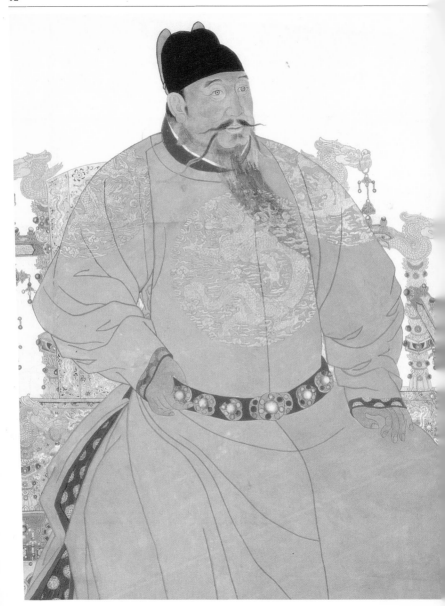

In the fourth year of his reign,
Yongle, the third Ming emperor,
decided to transfer the seat of power
from Nanjing to Beijing and to build
an immense palace at the heart of his
new capital. This imperial Forbidden
City, where the Manchu Qing dynasty
also established itself from 1644, was
to remain the sacred centre of the
empire for five hundred years, from
the 15th to the 20th century.

CHAPTER 1

THE WORK OF A MING EMPEROR

Wishing to reduce
the power of the
princes of royal blood,
Jianwen (1399–1402),
the second Ming
emperor, instigated the
rebellion of his uncle
Zhu Di, military
governor of the Beijing
region. In 1401 Zhu Di
marched on the capital,
Nanjing, and in 1403
came to the throne as
Yongle (opposite).
The dragon, symbol
of imperial power, can
be found all over the
Forbidden City (right).

[handwritten annotation] one piece of marble brought during winter – threw water on road to create ice – slid the slab to palace

From the Yuan to the Ming

The Mongol Yuan dynasty, which ruled China from 1276, was rapidly weakened by disputes over the succession, inflation, administrative inefficiency and corruption.

During the 1350s Chinese patriotism was reawakened, principally at the instigation of the secret Buddhist society of the Red Turbans whose leader, Han Shantong, was considered a reincarnation of Maitreya, the Buddha of future times. Peasant revolts broke out simultaneously in many provinces. In this period of chaos, Zhu Yuanzhang, a peasant endowed with great charisma and political intuition, gradually eclipsed all the other rebel leaders and took control.

He was wise enough to prevent his men from plundering, thus earning the unconditional support of the inhabitants of all the regions he conquered.

In 1368, following a string of victories, he arrived in Beijing with his troops to find that the Mongols had already fled. In the same year he founded, in Nanjing, a new dynasty, which was called the Ming, and reigned under the name of Hongwu (1368–98).

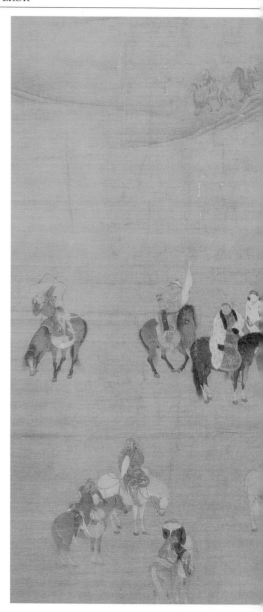

Expansion and peak of the Ming empire

In addition to his talent as a leader in battle, Hongwu also proved to be a skilled administrator. He implemented an ambitious programme of economic reconstruction, paying particular attention to agriculture. Reafforestation, irrigation and the reclaiming of fallow land characterized his thirty-year reign, laying the foundations for the splendour and prosperity that China was to enjoy in the 15th century. His policy was to be pursued by Yongle (1403–24), the third Ming emperor and one of the most renowned in the whole of China's history.

The empire continued to be burdened by the Mongol threat and Yongle wished to be able to retaliate rapidly in the event of attempted raids. The ruler therefore decided to transfer the political centre of his empire to the northern border, making Beijing its capital.

This city situated on the frontier of the Chinese and 'barbarian' worlds already had a long history. An important commercial centre since the 9th century BC, seat of the principality of Yan in the 5th century BC, it had been the capital of the Liao (907–1125) and subsequently of the Jin (1125–1234), before becoming the Great Capital or Dadu of the Yuan, the City of the Khan (Khanbalik) created by Kubilai Khan in 1267 and described by Marco Polo (1254–1324) in his *Travels of Marco Polo*.

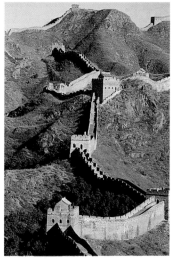

Qin Shihuangdi (221–210 BC), who unified China, had strengthened his empire's northern defences by linking up the eart-hern walls erected in the 3rd century BC by the states of Yan and Zhao as protection against the barbarians. Further south, the Ming emperor Chenghua had a new wall built in stone during the 1470s. By 1644 the wall (above) stretched almost 6400 km from east to west, from the Yalu river to the Gobi desert.

This scroll (left) from 1280, attributed to Liu Guandao, shows Kubilai Khan indulging in one of his favourite pastimes of hunting.

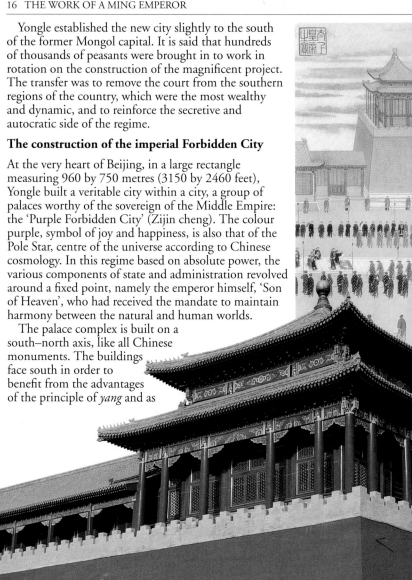

Yongle established the new city slightly to the south of the former Mongol capital. It is said that hundreds of thousands of peasants were brought in to work in rotation on the construction of the magnificent project. The transfer was to remove the court from the southern regions of the country, which were the most wealthy and dynamic, and to reinforce the secretive and autocratic side of the regime.

The construction of the imperial Forbidden City

At the very heart of Beijing, in a large rectangle measuring 960 by 750 metres (3150 by 2460 feet), Yongle built a veritable city within a city, a group of palaces worthy of the sovereign of the Middle Empire: the 'Purple Forbidden City' (Zijin cheng). The colour purple, symbol of joy and happiness, is also that of the Pole Star, centre of the universe according to Chinese cosmology. In this regime based on absolute power, the various components of state and administration revolved around a fixed point, namely the emperor himself, 'Son of Heaven', who had received the mandate to maintain harmony between the natural and human worlds.

The palace complex is built on a south–north axis, like all Chinese monuments. The buildings face south in order to benefit from the advantages of the principle of *yang* and as

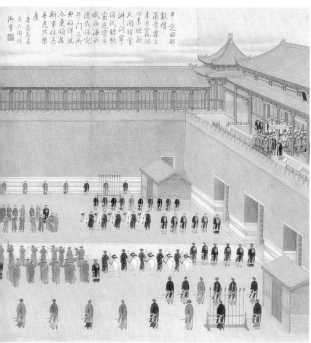

The main entrance to the Forbidden City, the Meridian Gate (Wu men; left) is the most imposing of all. Officials had to descend from their horses or their palanquins in front of the Meridian Gate and enter the city-palace on foot. From the great pavilion crowning the central section of the building, the sovereign presided over the inspection (left, of prisoners of war) staged upon the departure and the return of military expeditions. On the fifteenth day of the first lunar month, the Ming emperors received ministers and high-ranking dignitaries here for a great banquet, which provided the occasion for sparring matches in poetry.

On each of the side bastions of the Meridian Gate (left) were two pavilions whose elegant double-eaved roofs echoed those of the great central pavilion. This gate complex was known by the evocative title of the 'Five Towers of the Phoenix' (Wufeng lou).

protection against the harmful *yin* effects from the north – cold winds, evil spirits and warriors from the steppes. Impressive ramparts of packed-down earth faced with bricks, 10 metres (32 feet) high, coupled with drainage ditches 50 metres (165 feet) wide, isolated the palace from the city. Only four monumental gateways, situated at the four cardinal points, provided access from the imperial Forbidden City to the outside. Between 1407 and 1420 almost 200,000 labourers were to work on this building site measuring 720,000 square metres (7,747,200 square feet). The stone used in the construction was taken from the quarries of Fangshan, not far from Beijing. The marble came from Xuzhou, in Jiangsu, while the bricks were manufactured in Linqing, in the

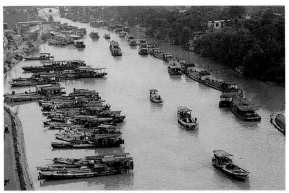

In order to link the imperial cities of Chang'an (modern-day Xi'an) and Luoyang, on the Huanghe (Yellow River), to the rice basin of the Lower Yangzi, the emperors of the Sui dynasty (581–618) created a network of navigable waterways which they extended, in 608, to Beijing with a canal 1500 km (930 miles) long that doubled as an imperial route. This Great Canal (left) was restored by Yongle to supply Beijing, his new capital, with building materials, grain and other commodities.

Shandong peninsula, more than 500 km (310 miles) to the south-east of the capital. The timber was brought from the provinces of Sichuan, Guizhou and Yunnan, more than 2000 km (1240 miles) from Beijing as the crow flies. A quarter of the journey was carried out on the Great Canal, which, for centuries, had linked the north and south of the country and which was restored between 1411 and 1415. In 1421 Yongle inaugurated the new imperial residence. According to one legend, the Forbidden City numbers 9999 rooms (it actually has 8886), a highly symbolic figure, since 9 represents the power of the principle of *yang* at its peak.

Yongle wished to restore China to the dominant position it had held in Asia at the beginning of the 14th century. His armies occupied the Annam region in the south, and Manchuria, up to the mouth of the Amur river in the north. He maintained diplomatic relations with numerous countries in Asia. Drawing on maritime traditions going back to the 11th century, he also strengthened the Chinese fleet and organized expeditions to distant places to which neither the Spanish nor the Portuguese had then ventured. Chinese vessels were to be found in Indonesia, India, in the port of Jeddah, near Mecca, and as far as the eastern shores of Africa.

How the Ming empire foundered

At the end of the 16th century the empire encountered serious difficulties. Insecurity was rife on the Mongol border, to the north-west, and the Chinese were forced

In this aerial view (opposite) of the Forbidden City, the spacious and symmetric arrangement of the Three Front Halls, theatre of political life, to the south, is in contrast to the complex and more crowded plan of the inner palaces, reserved for private life, to the north. The great ceremonial buildings that follow in sequence along the central axis barely cover one-sixteenth of the 72-hectare (180-acre) site, the premises devoted to the service and upkeep of this veritable city occupying a considerable area.

to come to the aid of the Koreans when the Japanese armies of the shogun (or military dictator) Hideyoshi landed on the peninsula in 1592. The lavish lifestyle of the court, the allowances and lands granted to increasingly numerous members of the imperial family led to increases in taxes and to a partial depopulation of the countryside. Many peasants abandoned their land, sought refuge in the mountains and formed armed bands.

The excessively ritualized life of the emperors distracted them from the management of their affairs. At the end of the reign of Wanli (1573–1620) and during that of Tianqi (1621–27), the government was destabilized by the power struggles between the Confucian government officials assembled around the Donglin Academy and the eunuchs led by Wei Zhongxian, who used his secret police to maintain his hold on the administration. As the financial crisis worsened, the government was forced to make considerable increases in commercial taxes, provoking riots in the towns. Once again, religious sects like the White Lotus Society revealed their subversive aims, while some mercenaries, who were badly paid and ill-fed, rose in revolt in 1627.

By 1636 two large regions were in a state of virtual secession: one in northern China (Shaanxi and Henan), run by Li Zicheng; the other, in the south in the Yangzi

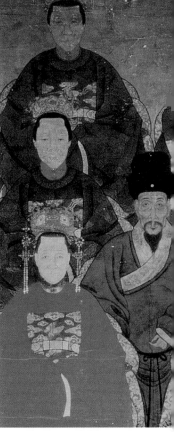

The Chinese worshipped their ancestors and executed numerous portraits during the Ming and Qing periods, often displaying a high degree of realism. This painting by an unknown artist of the Ming period (above) depicts a family of note.

basin and in Sichuan, governed by Zhang Xianzhong. In 1644, upon learning that Li Zicheng had seized Beijing, that Emperor Chongzhen (1628–44) had committed suicide, and that Li Zicheng had dared to establish himself on the throne, General Wu Sangui (1612–78) decided to call on the Manchu armies to expel the bandit from Beijing. The Manchus entered the capital without encountering any opposition but they set about conquering China for themselves. The year 1644 thus marks the fall of the Ming, a dynasty that ruled for almost three hundred years.

Yongle and most of his successors lie with their wives and concubines in a necropolis covering 18 square km (7 square miles), situated 50 km (30 miles) north-east of Beijing. Based on the tomb of Hongwu at Nanjing, the sacred way leading to Yongle's mausoleum is guarded by 36 colossi: 24 mytho-logical animals and 12 mandarins (three shown here).

The Manchus, the new masters of China

Who were the proud Manchus? Of Tungusic origin, they came in the distant past from southern Siberia and were descended from the Jurchen stock-breeders who founded the Jin empire on the north-eastern frontiers of China in 1115. In 1125 the Jin destroyed the empire of the Liao – another sinicized 'barbarian' dynasty – and extended their control to the whole of northern China a year later, forcing the heir of the Song to seek refuge at Hangzhou in the south. Driven out by the Mongol armies of the Yuan in 1234, the Jurchen allied themselves with the Ming at the end of the 16th century to fight against the Japanese in Korea.

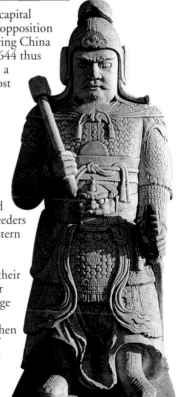

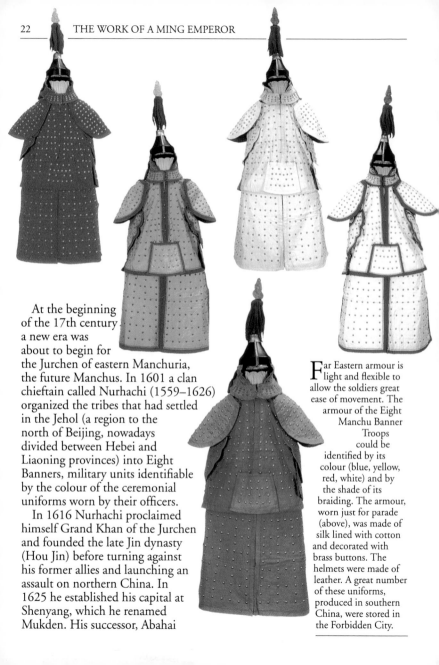

At the beginning of the 17th century a new era was about to begin for the Jurchen of eastern Manchuria, the future Manchus. In 1601 a clan chieftain called Nurhachi (1559–1626) organized the tribes that had settled in the Jehol (a region to the north of Beijing, nowadays divided between Hebei and Liaoning provinces) into Eight Banners, military units identifiable by the colour of the ceremonial uniforms worn by their officers.

In 1616 Nurhachi proclaimed himself Grand Khan of the Jurchen and founded the late Jin dynasty (Hou Jin) before turning against his former allies and launching an assault on northern China. In 1625 he established his capital at Shenyang, which he renamed Mukden. His successor, Abahai

Far Eastern armour is light and flexible to allow the soldiers great ease of movement. The armour of the Eight Manchu Banner Troops could be identified by its colour (blue, yellow, red, white) and by the shade of its braiding. The armour, worn just for parade (above), was made of silk lined with cotton and decorated with brass buttons. The helmets were made of leather. A great number of these uniforms, produced in southern China, were stored in the Forbidden City.

(1627–44) changed the name Jurchen to
Manchu in 1635 and, in the following year,
altered the title of his dynasty to Qing.
His entire policy was aimed at adopting
Chinese customs. Thus the palace
he had built in Mukden was
based on the Forbidden City
in Beijing, although clearly on
a more modest scale. His advisors were
Chinese generals, while the Booi,
Chinese long-established in Manchuria
and perfectly bilingual,
constituted the core of the
administration after the
conquest of the empire.

A new dynasty: the Qing

Northern China, which had fallen prey
to serious anarchy, put up little
resistance to the conquerors. When
Beijing was seized in 1644,
one of Abahai's sons was able
to ascend the imperial throne
under the name of Shunzhi
(1644–61).

The heirs of the
Ming, who had
withdrawn to Nanjing,
attempted to resist the
Manchu invaders, but they
were rapidly defeated. In
1645, following the fall of
Yangzhou and of Nanjing,
the Ming from the south
were to begin a long period
of wandering, from Fujian
to Guangdong, from
Guangxi to Yunnan,
where they were finally to
be crushed by Wu Sangui,
appointed governor of the
province by the Qing.

Under Abahai, the
Banners increased.
Chinese renegades were
incorporated into the
outer Banners, while
the Jurchen and
their Mongol allies
constituted the inner
Banners. When the
Manchus swept
through the
country, their
army consisted
of 169,000 men.
Until the 18th century
the military authorities
were concentrated in
Beijing. In the 19th
century recruitment,
logistics and even
strategy were delegated
to provincial
governors.

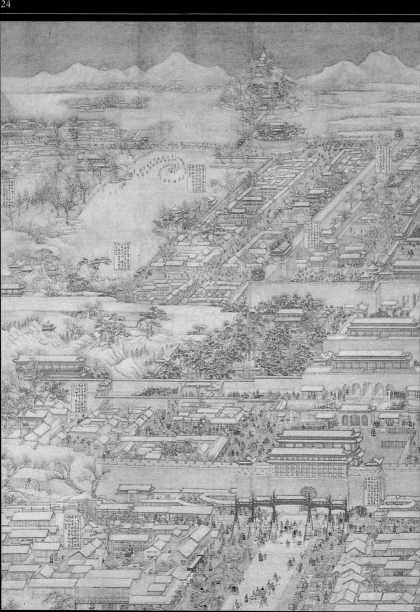

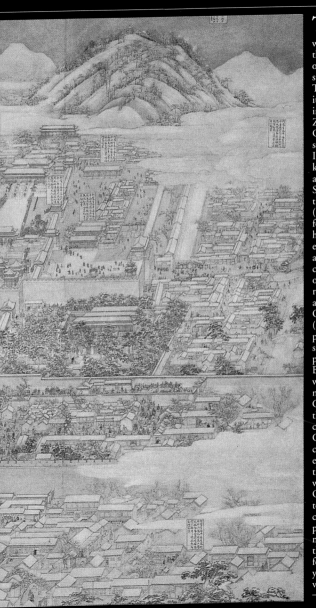

This scroll shows Beijing in the winter of 1770. In the foreground the outer, or Chinese, city is spread out, while the Temple of Heaven and its huge park are visible in the bottom right. The Zhengyang Gate (or Gate facing the Sun) separates it from the Inner City, the private kingdom of the Manchu and Mongol aristocracy. Solid ramparts enclosed the Imperial City (Huang Cheng), a fortified square of 500 hectares (1235 acres) embellished with parks and lakes, which contained the palaces of the princes of royal blood and the administration. On the Central Lake (Zhonghai) to the west, people can be seen skating, while it is possible to make out Beihai Park and its white Dagoba to the north with, on the right, Coal Hill (Meishan). At the heart of the imperial city lies the Forbidden City, centre of the capital and of the empire. The painting, the work of Xu Yang, was inspired by Emperor Qianlong's poem 'Ode to Spring'. Invited to court in 1751, Xu Yang proved to be one of the most gifted artists in the imperial workshops for the next fifteen years, painting in a variety of genres.

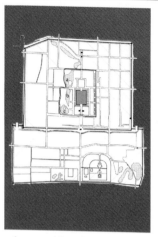

During the first decades of their domination, the Manchus established a fiercely inegalitarian regime, rather like the Mongol Yuan dynasty in the 13th century. Discriminatory measures were adopted against the native population: mixed marriages were prohibited; separate neighbourhoods were established in the big cities; it became compulsory, on pain of death, to wear a plait — a measure the Chinese, who considered this custom 'barbarous', found humiliating; widespread confiscation of peasant land

Beijing under the Qing dynasty (left), with the Inner City to the north and the Outer City to the south.

Anxious to preserve the warrior traditions of their nomadic ancestors, the Qing emperors attached great importance to

hunting. In the spring they took their soldiers on tiger hunts in an imperial park to the south of Beijing. In 1755, on one of these occasions, Father Castiglione, a Jesuit in the service of Qianlong,

occurred in northern China in order to provide the Manchu princes with substantial tracts of land and finally, in 1668, emigration to Manchuria was banned in order to protect the region from all foreign influence. Prisoners of war and peasants provided a workforce that could be infinitely exploited.

Beijing was divided into two. The northern part, the largest and most splendid, became the inner or 'Tartar' city. All its Chinese inhabitants were driven out and

painted these two horsemen.

forced to pack into the outer city to the south, the ancient fortified suburb housing several shrines, including the famous Temple of Heaven and Beijing's Great Mosque, as well as some particularly lively markets.

In the midst of the great upheavals caused by the fall of the Ming, one thing at least remained unchanged: the new emperors maintained Beijing as their capital, staying close to the northern frontiers of the empire. The reasons that led them to preserve the monumental

In 1703 Kangxi decided to have a summer palace built at Jehol (modern-day Chengde), 250 km north-east of Beijing, on the site from which his ancestors had set out on their conquest of China. The building of his retreat was to be completed in the reign

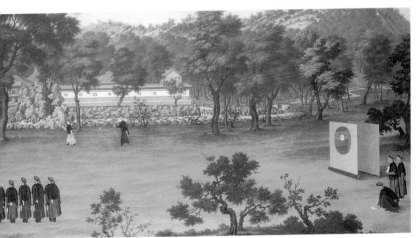

surroundings of their predecessors are not known, since Chinese tradition dictated that the palaces of previous dynasties were to be abandoned. The Manchus wanted to restore the palaces and to make their own mark on them, but they never succeeded in destroying the imprint of Yongle, the founder.

of his grandson Qianlong. The autumn hunts to which the Mongol princes were invited involved thousands of soldiers. At the same time equestrian jousts and archery contests (above) took place in the park of the summer palace as a means of maintaining good relations with the peoples 'united' under the empire while demonstrating Chinese military capacity.

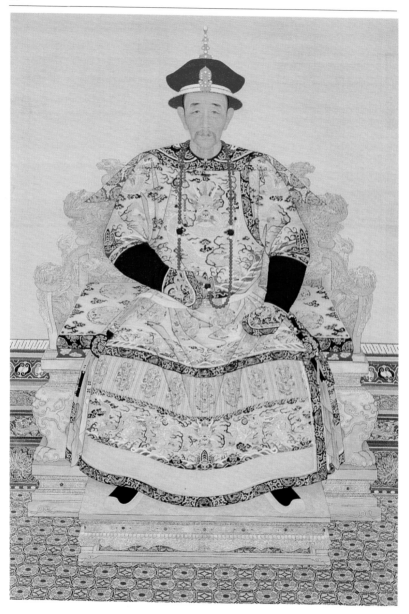

The two great Manchu emperors Kangxi and Yongzheng adopted much of the rigid protocol and ritualized life of the Ming rulers. The succession of ceremonial palaces along the north–south axis of the Forbidden City provided the unchanging setting for the exercise of power and the official and private ceremonies that marked the winter months.

CHAPTER 2

THE QING EMPERORS

Portraits of Kangxi in his maturity (opposite) have been bequeathed to us by his contemporaries. Quite tall and well-built, he possessed a lively mind, good judgment and an excellent memory.

Right: the Hall of Supreme Harmony with the Hall of Middle Harmony and the Hall of Protecting Harmony visible in the background.

Kangxi, a humanist despot

On his deathbed, Shunzhi, the first Manchu emperor (1644–61), designated as his heir his third son Xuanye, then seven years old. The future Kangxi already displayed notable qualities: a marked taste for study, a steady temperament coupled with great self-possession.

In 1669, encouraged by his grandmother, the Empress Dowager Xiaozhuang, Kangxi dismissed his regents and assumed the reins of power. Right at the beginning of his reign, the young emperor resolved a serious crisis by suppressing the Three Feudatories Revolt (1673–81) – the secession of the governors of the provinces of Yunnan, Guangdong and Fujian. At the same time, the Manchu armies completed the pacification of China. The new order was definitively established in 1683, even though rebellions broke out sporadically in the mountainous marches of the south-east. After several decades of Manchu domination, the inclination to exploit the country brutally and systematically reached its height, and the conquerors, a minority in the vast empire they governed, realized that it was in their interests to reconcile the various strata of the Chinese population. Kangxi thus took a series of measures to mitigate the most excessive characteristics of the segregationist policy followed up until then by the Qing.

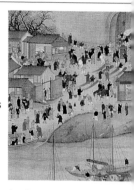

The reign of Kangxi (1662–1722) was characterized by unprecedented agricultural development. Small farmers were moderately taxed and an edict passed in 1711 limited the quotas they had to pay to the state. Crafts and commerce also flourished. The textile industry provided the peasantry (below) with additional work. In the 17th century China had a prosperous economy that was the envy of many a European country.

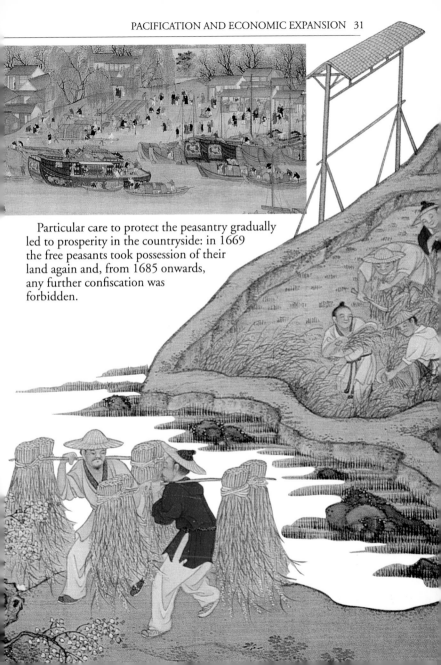

Particular care to protect the peasantry gradually led to prosperity in the countryside: in 1669 the free peasants took possession of their land again and, from 1685 onwards, any further confiscation was forbidden.

Kangxi also wished to gain the support of the former ruling classes. They were gradually won over to the new dynasty by the prestige of a career in the administration, which provided access to important posts in the machinery of the state. Moreover, the better paid the officials, the less inclined they would be to turn to corruption, the scourge of the Chinese administration.

While Neo-Confucian philosophy extolled the virtues of obedience and respect for the emperor throughout the empire, Kangxi, never forgetting his Manchu origins, scrupulously performed his role as Son of Heaven, father of the Han nation and guardian of its traditions. He showed great admiration for Chinese culture, particularly literature. On several occasions he had himself portrayed while reading in his library.

Like Qianlong after him, he took an interest in publishing: the compilation of a *History of the Ming*, of encyclopedias and literary anthologies and of dictionaries of all descriptions was to provide numerous scholars with steady employment for several decades.

Genuine intellectual interest, coupled with an acute political sense, also led Kangxi to make six tours of inspection in the regions of the Lower Yangzi, the cradle of Chinese civilization.

At the same time, the second Qing emperor followed a policy of pacification with regard to the peoples of the steppes, alternating negotiation with military campaigns. He became the protector *par excellence* of Tibetan Buddhism or Lamaism, the religion practised notably by the western Mongols (Koshots,

Kangxi, a great admirer of the painter and calligrapher Dong Qichang (1555–1636), executed an impressive amount of calligraphy himself. At the time of his visit to the south in 1703, he must have distributed almost 500 examples. The poem partially reproduced on these pages evokes vegetation caught by the cold in winter.

There are many Chinese portraits of Kangxi reading (opposite). These paintings testify to the emperor's interest in classical literature, while also serving as a manifesto: they present the Manchu sovereign as the guardian of Chinese traditions *par excellence*.

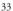

Torguts, Dzungars) who, allied to the fifth Dalai Lama, had unified Tibet in his name.

From the 1670s the Dzungars gradually extended their authority over vast tracts of central Asia and along the Silk Route, but Kangxi succeeded in destroying their hegemonic power and in securing the vassalage of northern Mongolia in 1691 and Tibet in 1720.

The Jesuits at court

Jesuit missionaries from the West gained Kangxi's protection and respect through their scientific knowledge and their artistic skills. These same talents had earned them a favourable reception by the last Ming emperors and Shunzhi, the first Manchu emperor.

As Son of Heaven, the sovereign was master of the calendar. He had to determine the cycle of

the seasons in order to ensure good harvests and observe the movements of the celestial bodies in order to reconcile the human and natural order.

Thus the annual publication of an official almanach determining the various religious festivals and agricultural work was of the utmost importance.

Gold armillary sphere from the Qianlong period (above).

Thanks to the discoveries of Western astronomers like Johannes Kepler, the Jesuits introduced methods of calculation that were much more precise than those of their Chinese counterparts. In 1645 the German Adam Schall von Bell (1592–1666) was awarded the directorship of the Board of Astronomy in Beijing. His treatise on astronomy was officially adopted by the court. In 1650 Father Schall obtained permission from Shunzhi to establish the first Catholic church in Beijing and he became one of the private tutors to the future Kangxi.

From 1668 to 1669 a dispute occurred between the Flemish Ferdinand Verbiest (1628–88) and the astronomer Yang Guangxian, a Chinese convert to Islam who presided over the Office of Mathematics. As a result of errors in the calendar pointed out by Verbiest, Yang Guangxian was dismissed and sent into exile, while Father Verbiest replaced him at the head of the prestigious imperial institution.

In 1688 Verbiest was succeeded by the Portuguese Thomas Pereira (1645–1703). The Frenchman Jean-François Gerbillon (1654–1707) also enjoyed Kangxi's favour. On his advice, the sovereign ordered a cartographic survey of his entire empire, allowing the *Huangyu Quanlantu* or *Atlas of Kangxi*, an extremely accurate work for the time, to be engraved on copper plates in 1718. These two Jesuits served as plenipotentiaries in the negotiations between the Chinese and the Russians regarding the borders of the two empires. The Treaty of Nerchinsk (1689), favourable to China, was partly their work.

In 1692, by an edict of tolerance, the emperor granted the Jesuits, who had nursed him through a serious attack of malaria with quinine imported from America, the right to preach freely in China. The progress of Catholicism in the country, however, was rapidly hindered by the Vatican's intransigence in the famous Rites Controversy (1693–1715).

Father Schall (opposite) and Father Verbiest (below) shown here wearing Mandarin costume. Accused of plotting against the state by Yang Guangxian in 1664, Father Schall was arrested and condemned to death the following year by the regents. An earthquake – seen as a heavenly sign – saved the scholar's life. In 1674, at Kangxi's request, Father Verbiest perfected a series of astronomical instruments that were placed on the terrace of the Imperial Observatory in Beijing. Missionaries from the West were to remain in charge of the Board of Astronomy until 1838.

While the missionaries tolerated Chinese rites (sacrifices made to their own ancestors and to Confucius, the worship of Heaven), two papal legates, Charles Maigrot and Charles de Tournon, irrevocably condemned these 'superstitious' practices and the Pope soon charged the Jesuits with ensuring that these interdicts were respected. Kangxi supported the Jesuits, specifying however: 'As for the Western doctrine which exalts the Lord of Heaven (Tianshu), this is contrary to the orthodoxy [of our sacred books] and it is only because its apostles have a profound knowledge of the mathematical sciences that the state employs them'. In 1720 the controversy subsided thanks to the more conciliatory attitude of another papal legate, Jean Ambroise Mezzabarba.

The reign of Yongzheng

The end of Kangxi's long reign was marred by the intrigues that set his heirs apparent against each other. In the end the emperor chose his eleventh son, Prince Yingzhen, as his successor.

Hardly had the ruler ascended the throne under the name of Yongzheng (Justice and Concord) in 1723 than he hastened to eliminate or exile all his potential opponents, including his half-brothers and their supporters. In 1727 he sent all the missionaries who

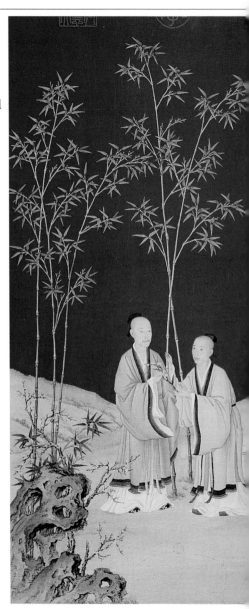

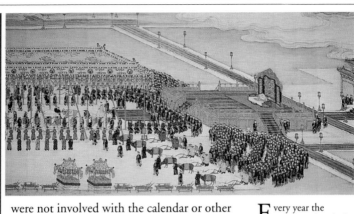

寫真世寧控我少
年時入宮瞻然者不

were not involved with the calendar or other imperial functions to Macao. The same year, a treaty that was to constitute the basis of relations with Russia for over a century was signed at Kiakhta.

An indefatigable worker with an exalted idea of his role, Yongzheng was very favourably inclined towards agriculture. He ensured that rice was distributed to the peasants in years of bad harvest and took drastic measures to aid the population of Beijing and the surrounding area in the wake of the devastating earthquake of 1730.

Anxious, like his father, to win over the Chinese elite, Yongzheng restructured the organs of government in 1732. He suppressed the Manchu members of the council of state, who had until then been consulted on matters of importance, and created a high court of the emperor's secrets, a sort of great council whose members were chosen from the upper levels of the administration on the basis of their rank and character. Mindful of the quarrels over the succession that preceded his own accession, he established a system enabling the reigning sovereign to choose his successor in secret, free from any possible dispute. He was to put this into practice in the case of his son Hongli, the future Qianlong.

Every year the emperor ploughed the first furrow to bless the earth and preserve its fertility (above). This rite, one of the most sacred in the empire, took place in the vast enclosure of the Altar of the God of Agriculture, to the west of the Temple of Heaven, in the 'Chinese' city.

Father Castiglione (1698–1766) arrived in Beijing in 1715, soon entering the imperial workshops under the name of Lang Shining (World of Peace). The scroll entitled *Tranquil Spring* but unsigned (opposite) is unusual in his oeuvre. This study illustrates the theme of the passage of time. It represents Qianlong in his youth, in the company of Yongzheng, his father. In the inscription Qianlong compares his appearance at the time to that of the old man he has become.

A winter palace for the Son of Heaven

From November to February, Kangxi and Yongzheng resided in the Forbidden City. This monumental complex, both symmetric and labyrinthine in plan, develops the traditional layout of the Chinese dwelling to the point of excess: pavilions arranged around one or several courtyards, with the reception rooms at the front (to the south), the private rooms to the north and the adjacent buildings to the east and west.

In the part to the front of the palatial complex, known as the Outer Court (Wai chao), monumental gates, courtyards and imposing official buildings (the Three Front Halls) succeed one another along the central axis, running strictly from north to south.

In the part to the rear – the Inner Court (Nei chao) – a fresh succession of buildings echoes this plan on a smaller scale. Three palaces reserved for events marking the private life of the emperors and a huge garden are dotted along the central axis, the apartments and outbuildings being relegated to the lateral axes. The layout of the complex has hardly changed since the 15th century, despite continuous alteration and renovation.

A remarkable succession of buildings

A vast perimeter separates the Gate of Heavenly Peace (Tianan men), the southern entrance, from that of the Forbidden City. Its two central courtyards, separated by the Gate of Uprightness (Duan men), were allocated for military parades. In the parks, to the east and to the west, rise the ancient Temple of the Imperial Ancestors (Tai miao) and the Altar of the Sun and the Harvests (Sheji tan).

The main entrance to the Forbidden City, the Meridian Gate (Wu men) [1], is a massive horseshoe-shaped construction. The central part is surmounted by a pavilion nine bays wide, where the emperor promulgated the new calendar every year and from where he presided over the great military parades.

Forbidden City plan

1. Meridian Gate;
2. Bridges over Golden Water; 3. Gate of Supreme Harmony;
4. Hall of Supreme Harmony; 5. Hall of Middle Harmony;
6. Hall of Protecting Harmony; 7. Gate of Heavenly Purity;
8. Palace of Heavenly Purity; 9. Hall of Union; 10. Palace of Earthly Tranquillity;
11. Imperial Garden;
12. Pavilion of a Thousand Autumns;
13. Pavilion of Ten Thousand Springs;
14. Gate of Applied Righteousness;
15. Gate of Divine Military Genius;
16. Hall of Mental Cultivation; 17. Office of the Imperial Kitchen;
18. Six West Palaces;
19. Palace of Concentrated Beauty;
20. Palace of Eternal Spring; 21. Six East Palaces; 22. Palace of Peaceful Longevity;
23. Pavilion of the Flowering of Buddhism;
24. Pavilion of Pleasant Sounds; 25. Pavilion of the Rain of Flowers; 26. Palace of Benevolent Tranquillity; 27. Great Seat of the Imperial Secretariat.

[Subsequent numbers in square brackets in the text relate to this plan.]

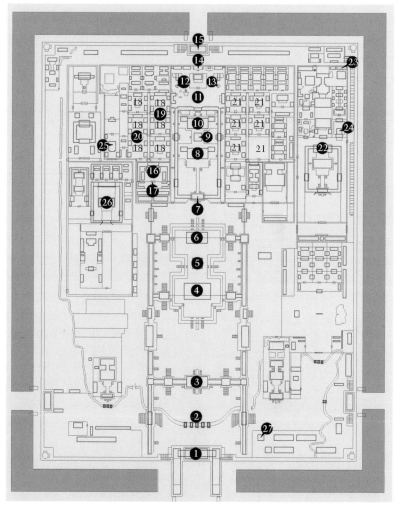

The Meridian Gate also has two large fortified wings, crowned at each end by square pavilions. Two of these contain drums, while the other two contain bells. The drum was beaten whenever the emperor went to the Temple of the Imperial Ancestors, and the bells were rung when he visited other sites of imperial worship.

This finely chiselled and gilded bronze bell (opposite), dated 1744, is typical of the production of the imperial workshops.

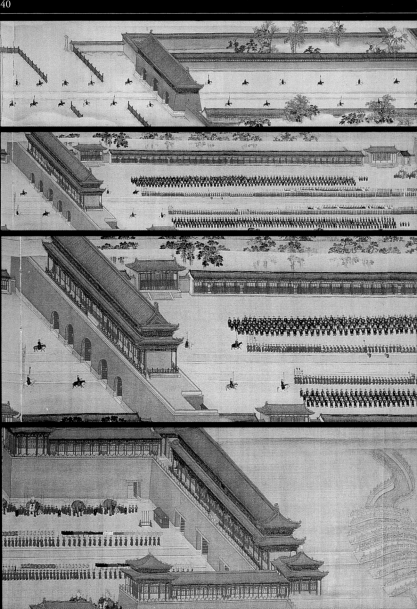

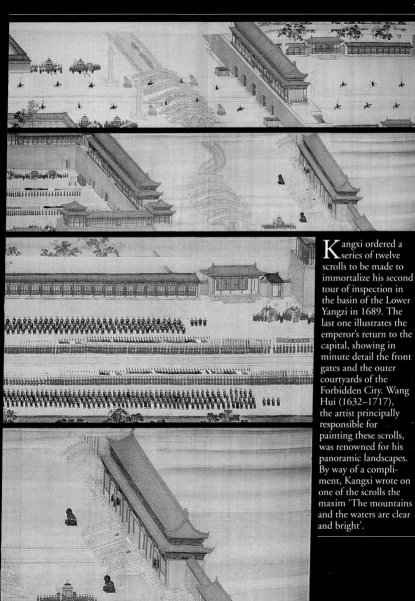

Kangxi ordered a series of twelve scrolls to be made to immortalize his second tour of inspection in the basin of the Lower Yangzi in 1689. The last one illustrates the emperor's return to the capital, showing in minute detail the front gates and the outer courtyards of the Forbidden City. Wang Hui (1632–1717), the artist principally responsible for painting these scrolls, was renowned for his panoramic landscapes. By way of a compliment, Kangxi wrote on one of the scrolls the maxim 'The mountains and the waters are clear and bright'.

The facade of the Meridian Gate has three vaulted passages set into it and each of the two wings has a side gate. The central passage was reserved for the emperor's comings and goings, for the empress' entry into the Forbidden City on the day of her marriage and for the exit of the three winners of the imperial examinations on the day they were appointed.

For all the great ceremonies, high-ranking dignitaries arrived before the Meridian Gate and lined up, in rank, at the first roll of the drum. At the second, the officials of the Board of Rites opened the side gates to allow them to enter the Forbidden City. At the third, the sovereign appeared on the platform and sat on the throne. In front of the eastern wing of the Meridian Gate, the high-ranking civil servants who had offended the emperor also received their beatings.

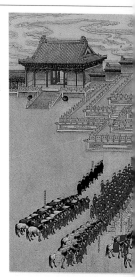

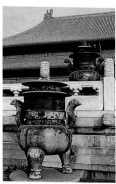

The Meridian Gate opens on to a courtyard 200 metres (650 feet) long and 130 metres (420 feet) wide, crossed by the river of Golden Water (Jinshui he) [2]. Five bridges, symbolizing the five cardinal virtues of Confucianism, straddle this small river. At the end of the courtyard, along the axis of the central bridge, the Gate of Supreme Harmony (Taihe men) [3] opens on to an imposing white marble terrace with three steps. It is flanked by secondary doorways, the Gate of Luminous Virtue (Zhaode men) and the Gate of Correct Conduct (Zhendu men).

The great ceremonial courtyard

The Gate of Supreme Harmony leads into the largest courtyard in the whole palace (measuring 200 by 190 metres – 650 by 620 feet). The galleries running all around it housed the libraries and the imperial storerooms containing, in thirty-three separate rooms, weapons, vases, furs, silks, pearls and precious stones, and rare objects which were to be used by the imperial family or which the emperor could present to subjects

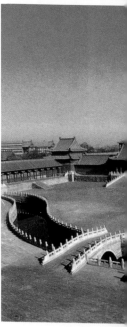

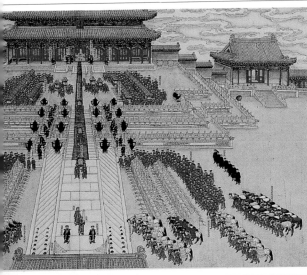

In front of the Hall of Supreme Harmony, eighteen incense burners symbolize the eighteen provinces of the empire (opposite).

The wedding of Guangxu and Xiaoding, in 1889, was one of the last great ceremonies in imperial China. The presents were laid in front of the Hall of Supreme Harmony (left).

The river of Golden Water and the Gate of Supreme Harmony (below).

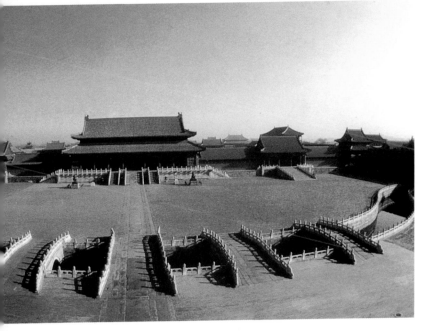

he wished to reward. Under the Ming emperors, a pavilion on the eastern side housed the 11,099 volumes of the famous *Encyclopedia of Yongle*.

In the centre of this immense courtyard, a triple white marble terrace 7 metres (23 feet) high forms a large rectangle narrowing sharply at its centre. Each of the three steps is encircled by a balustrade emphasized by gargoyles. Two magnificently proportioned staircases frame the long access ramp (50 metres – 165 feet) situated in the middle, delicately sculpted with coiled dragons. This imperial emblem is repeated on the bollards emphasizing the balustrades.

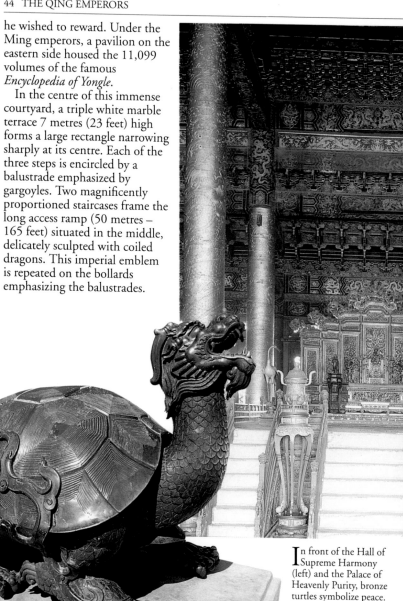

In front of the Hall of Supreme Harmony (left) and the Palace of Heavenly Purity, bronze turtles symbolize peace.

On this great platform are the Three Front Halls, the most splendid buildings in the Forbidden City.

The Hall of Supreme Harmony

In front of the first building, the Hall of Supreme Harmony (Taihe dian) [4], appear two symbols of imperial justice: in the left-hand corner of the terrace, a small pavilion that housed a grain-measure and, in the right-hand corner, a sun dial.

This bronze lion, which guards the Gate of Supreme Harmony, dates from the Ming period.

The first ceremonial palace is a building measuring about 64 metres (210 feet) in width, 27 metres (88 feet) in height and with a depth of 37 metres (121 feet). Its 24 columns support a roof with a double curve with glazed yellow tiles.

The events marking the life of the empire were celebrated in this vast hypostyle hall: the enthronement of a new Son of Heaven, the sovereign's marriage and the Great Anniversary (every ten years), ceremonies marking the new lunar year and the winter solstice, the solemn proclamation of the results of the imperial examinations, the reading of decrees of paramount importance and the appointment of generals on the eve of military campaigns. Full orchestras of musicians, particularly using chimes of stones or golden bells, provided rhythm to the ceremonies.

Decorated entirely in red and gold, the Hall of Supreme Harmony (left) is the largest (2370 square metres – 7775 feet) and most sumptuous in the Forbidden City. The six columns demarcating the central section are gilded and decorated with stuccoed dragons; the others are lacquered in red. In former times, rich yellow carpets (the imperial colour) covered the floor. The throne and the screen behind it are in gilded rosewood decorated with dragons. Placed on pedestal tables around the dais are perfume burners and vases containing incense. The four large cupboards contained ritual objects.

From high on the throne erected on a platform with seven steps at the centre of the hall (and at the symbolic centre of the universe), the ruler presided over the ceremonies and received the homage of the high-ranking dignitaries and foreign ambassadors, thus enabling his civilizing goodness to shine over the Middle Empire and the world. Just above the imperial throne, in the central coffer of the richly decorated ceiling, two golden dragons play with a gigantic pearl.

On the occasion of imperial weddings and all other great official banquets, 108 tables could be erected inside the Hall of Supreme Harmony and 176 outside it.

The Hall of Middle Harmony

The Hall of Middle Harmony (Zhonghe dian) [5] occupies a square with sides measuring 16 metres (52 feet) in the centre of the terrace. This pavilion, known until 1645 as the Hall of Middle Supremacy, owes its present name to a quotation from the ancient *Book of Changes*: 'Avoid extremes and self-control brings harmony.' The emperor prepared himself here before sitting in the Hall of Supreme Harmony and also received ministers or ambassadors individually.

It was in the Hall of Middle Harmony that any announcements were prepared that were to be read in the imperial temples during the seasonal ceremonies and at the commemorative services held in the Imperial Ancestral Temple (Tai miao) and the Hall of Ancestral Worship (Fengxian dian).

Once a year, the ruler, several princes and high-ranking officials came together here to be presented with the ploughing implements and the fresh seeds needed to carry out ancient agrarian rituals. Lastly, every ten years and with great pomp, the Qing emperors examined the registers tracing the imperial ancestry in this hall.

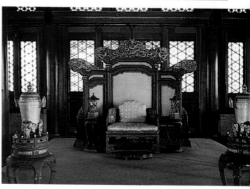

In the central aisle of all the audience halls in the palace (below) was a throne decorated to a greater or lesser extent and set against a screen. Precious perfume burners enhanced the majesty of the setting.

Jade disks (*bi*) pierced in the centre have been recorded in China since the fifth millennium BC. From the 8th century BC they have symbolized the heavens. According to the geometric norms attributed by Chinese cosmology to the universe, the heavens form a circle and the earth, a square. Copies of ancient jades (opposite) have been made since the 10th century, but were numerous in the 17th and 18th centuries. The dragons on this table screen symbolize the male and creative principle of *yang*, master of the heavens and the rain.

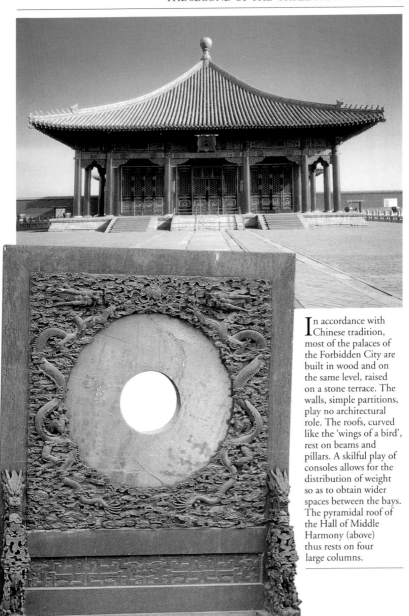

In accordance with Chinese tradition, most of the palaces of the Forbidden City are built in wood and on the same level, raised on a stone terrace. The walls, simple partitions, play no architectural role. The roofs, curved like the 'wings of a bird', rest on beams and pillars. A skilful play of consoles allows for the distribution of weight so as to obtain wider spaces between the bays. The pyramidal roof of the Hall of Middle Harmony (above) thus rests on four large columns.

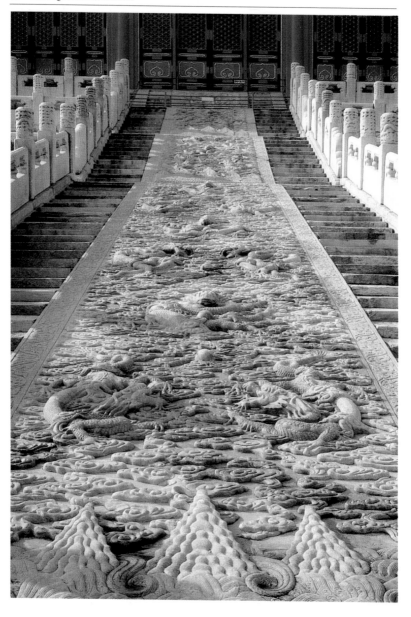

The Hall of Protecting Harmony

The third building, the Hall of Protecting Harmony (Baohe dian) [6], is built to the same plan as the Hall of Supreme Harmony. Initially known as the Hall of Respectful Care and Contentment then, in 1562, as the Hall of Establishing Supremacy, it acquired its present name, inspired by *The Book of Changes*, in the Qing era. It was here that the Manchu sovereigns organized great banquets in honour of their new sons-in-law. The first and the fifteenth day of the first lunar month, they received the vassal Turco-Mongol princes in this hall with unprecedented pomp. For the occasion, 10,000 sheep were sacrificed in 1903.

The collections of imperial edicts destined for the archives were also presented in this room. From 1789 the ruler received here the winners of the triennial examinations for the recruitment of officials in order to subject them to a final oral test before appointing them to posts in the higher administration.

Save for the empress on her wedding day, no women were admitted into these halls in the Outer Court, where the emperor essentially performed a ceremonial role.

The Gate of Heavenly Purity (Qianqing men) [7] separated the official part of the imperial palace from the private one.

The ceremonial palaces of the Inner Court

The three great buildings of the Outer Court were echoed by those of the Inner Court, also built on a single terrace.

The Palace of Heavenly Purity (Qianqing gong) [8], the first and most important of these, housed the apartments of the Ming and early Qing emperors. From the reign of Yongzheng, it served as an office

In the ceremonial areas of the Forbidden City, doors, steps and access ramps are always uneven in number. The central passageway, reserved for the ruler's palanquin, is often marked by slabs of white marble sculpted with dragons in low relief. Qianlong had the largest slab installed (16.57 metres – 54 feet long) behind the Hall of Protecting Harmony (opposite).

While the succession of doors produce skilful perspectives throughout the city-palace, pierced screens ensure that the rooms are ventilated in summer (above).

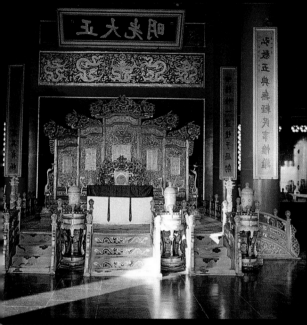

The layout of the Hall of Supreme Harmony is echoed, although on a smaller scale, in the Palace of Heavenly Purity (left), erected by Yongle but rebuilt in 1798. Emperor Tongzhi died in a small room adjoining it in 1874. The marriage of Puyi, in December 1922, was the last great ceremony held in this hall.

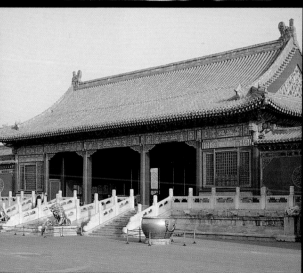

Only the bronze lions that guard the gates of the Inner Court are gilded (opposite page, one at the Gate of Heavenly Purity). Kangxi and his successors used to grant certain audiences beneath this gate (below left). The emperor arrived in a palanquin, to show everyone his determination to solve the problems of the empire. Beforehand, the head of the palace eunuchs set up a throne and a folding screen behind a table covered with a yellow cloth. Ministers and officials prostrated themselves on a yellow carpet in front of the table, before presenting their reports to the sovereign.

and audience chamber for officials, ambassadors and vassal princes. Banquets were held here for the New Year and other annual festivals. It was here that, in 1785, Qianlong presided over the celebrated banquet of the 'Ten Thousand Old Men', bringing together 3000 men over sixty years old from all four corners of the empire.

The deceased ruler's coffin was displayed in this palace before his funeral. In addition, Yongzheng conferred on this hall a particular function. In a sealed box hidden behind the palace's honorific tablet, the emperor deposited the name of the individual he considered most worthy to succeed him, and he carried with him a copy of the document. When he died, it was sufficient to compare the two documents in order to proclaim the name of the new Son of Heaven.

The second of these ceremonial palaces is conceived on a square plan like the Hall of Middle Harmony. This pavilion, known as the Hall of Union (Jiaotai dian) [9] initially constituted the empress' throne-room. The first wife of the emperor held audiences and celebrated New Year and her birthday here. From Qianlong's reign onwards, the imperial seals were kept here. Twenty-five in all and cut from various materials, they were used to sign different types of administrative documents, in accordance with the strict rules laid down by the fourth Qing emperor.

Lastly, the Palace of Earthly Tranquillity (Kunning gong) [10] served as a residence for the Ming empresses. The Manchus divided it into two parts, attributing to them two very particular functions: the smallest part became the the nuptial chamber for the imperial couple, and the other, a shrine dedicated to Manchu divinities who required daily offerings of meat, prepared in an adjacent kitchen.

The Imperial Garden

Situated to the rear of the Inner Court is the Imperial Garden (Yuhua yuan) [11], the largest in the Forbidden City, laid out in the 15th century. Like all Chinese gardens, it endeavours to provide an idealized image of nature, reconstructing, within a restricted space, its rhythms and different aspects. Ancient trees, twisted rocks on pedestals, the Pavilion of Ten Thousand

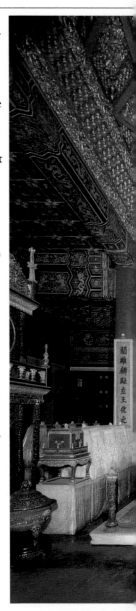

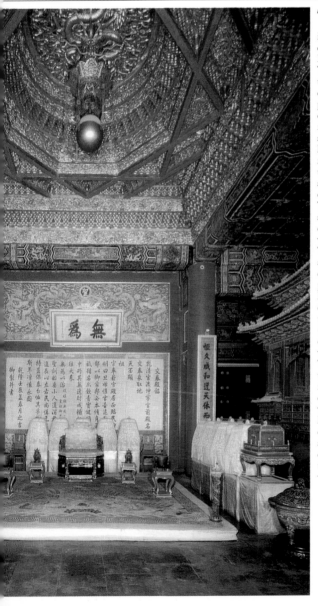

The ceiling of the Hall of Union is one of the most elaborate in the Forbidden City. The lateral triangles of the central group of coffers are sculpted with phoenix, the empress' emblems, while in the middle, a gilded dragon, symbol of the emperor, holds a giant pearl in its mouth. The union of these two mythological animals is the guarantee of a smooth succession. The twenty-five imperial seals were kept in caskets on pedestals, draped with yellow-satin covers. This hall also contains a monumental copper clepsydra, made in the palace in 1746, and a large chiming clock dating from 1798. The two characters *Wu Wei* ('abstain from action'), on the panel on the back wall, summarize the Taoist political ideal: not to disturb the course of nature and society by one's actions – the only way to be in complete harmony with the cosmos and hence, as far as the ruler was concerned, to maintain the heavenly mandate.

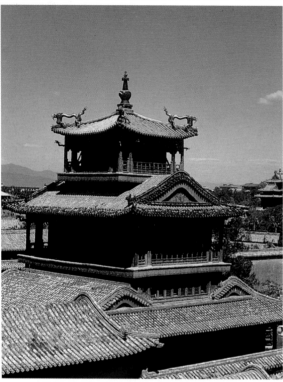

Springs [12] and the Pavilion of a Thousand Autumns [13], with roofs round like the heavens on a base square like the earth, express the harmony of the universe.

In the centre of the garden, the Hall of Imperial Tranquillity (Qin'an dian) is protected by a rectangular balustrade. On New Year's Day, the emperor came here to worship a water god belonging to the Taoist pantheon, charged with protecting the palace from fire.

The only dissymmetrical element in the arrangement, although highly symbolic in value, is a small artificial hill made from a pile of rocks that rises in the north-east corner of the garden. For the Double-Ninth Festival (the ninth day of the ninth lunar month), which consisted of climbing the highest summit in the region to send good wishes to relatives and friends who had left for distant

Above: the Hill of Accumulated Refinement and its Pavilion of the Imperial Prospect.

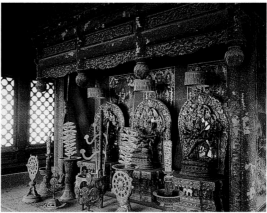

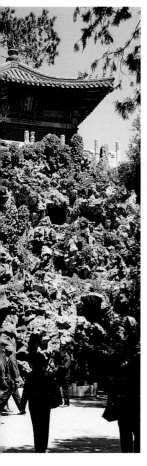

places, the imperial family assembled in the pavilion perched on this Hill of Accumulated Refinement (Duixiu shan), one of the rare places from which it was possible to see beyond the walls of the Forbidden City.

The temples

The palace contained numerous places of worship served by their respective clergy. The Taoist and Lamaist temples of the Ming were augmented by additional Lamaist shrines during the Manchu period, the Qing following the example of the Yuan and proclaiming themselves the defenders of Tibetan Buddhism.

Priestess-magicians also performed Manchu animist rituals in the palace. To the sound of drums, they went into a trance, making predictions and carrying out exorcisms.

The Pavilion of the Rain of Flowers (Yuhua ge) is the Forbidden City's principal Lamaist temple and its only building on several floors. It was erected by Qianlong in 1750, and based on the Tower of Initiation of mTho-ling in western Tibet. Each storey (above, the fourth) is dedicated to several divinities corresponding to a group of sacred texts (*tantra*). A dragon keeps watch at each corner of the roof with gilded copper tiles (far left).

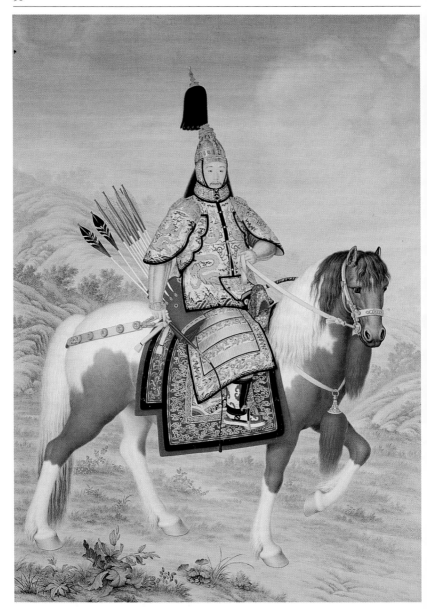

Qianlong, the ruler the Jesuit missionaries were to compare to Louis XIV, the Sun King, dominates the entire 18th century. Many alterations were carried out in the Forbidden City during his reign, notably in the Inner Court, the private domain of the emperors and their wives. The social and economic crisis that marred the final years of his reign foreshadowed the gradual decline of the dynasty.

CHAPTER 3

THE REIGN OF QIANLONG

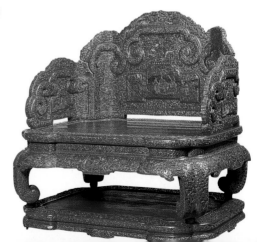

Painting on silk by the Jesuit Giuseppe Castiglione (opposite), showing Qianlong in ceremonial military dress. This throne (right), from the hunting lodge of Nanhaizi, south of Beijing, is testimony to the splendour of imperial furniture in the 18th century.

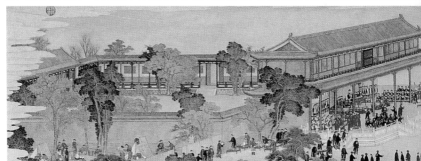

The Qing dynasty at its height

Yongzheng designated as his successor the only one
of his sons to have a Manchu mother: Prince Hongli,
born in 1711. Upon inheriting the empire in 1736,
this young man, who was sophisticated as well as erudite
with an imposing personality, chose to reign under the
name of Qianlong (Heavenly Glory).

Qianlong successfully pursued the paternalistic and
authoritarian policies of his two illustrious predecessors
and extended the boundaries of the empire. After
having annexed the Ili basin and annihilated its Dzungar
population, the Sino-Manchu armies conquered the
Islamized oases of the Tarim Basin. With these 'New
Territories' (Xinjiang), China reached the height of its
expansion in 1759: 11,500,000 square km (as compared
to the 9,700,000 square km it covers nowadays).

Its frontiers included the whole of Mongolia and
vast territories that are now part of Russia, while most of
the neighbouring countries recognized its suzerainty.

Despite uprisings of the ethnic minorities in the
outlying regions, the empire enjoyed a long period of
peace. Agriculture continued to develop thanks to the
introduction of new plants (sorghum, maize and sweet
potato), improvements in productivity and taxation
favourable to farmers. The progress of the craft industry,
characterized by the industrialization of certain sectors,
such as ceramics and textiles, and the increase in exports
(tea, paper, silk, porcelain, lacquer) to Asia and America
via the Philippines, and to Europe, brought great
prosperity to the country and led to the emergence
of a rich merchant class.

Above: the *Battle of
Yesilkolnoz*, painted
by Father Salusti, is one
of the sixteen works
depicting Qianlong's
conquests in upper Asia.

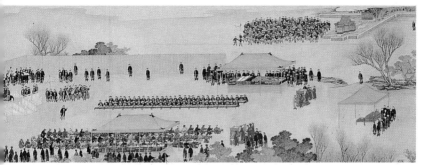

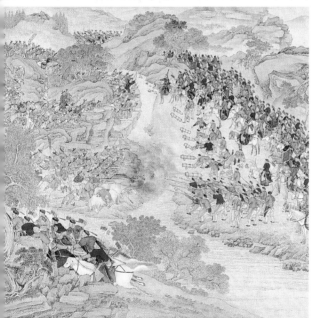

Above: in 1762 Qianlong held a banquet in front of the Purple Light Pavilion (Ziguang ge), to which he invited the officers and officials who had helped him in his conquest of Xinjiang, as well as the envoys of the new tributary nations.

Below: imperial seal from the reign of Qianlong and its impression.

 This economic expansion was coupled with a spectacular growth in population, due partly to the decline of certain diseases, such as smallpox. The population increased from approximately 143 million inhabitants in 1740 to 313 million in 1790.

Qianlong, scholar, aesthete and patron

A sophisticated scholar, Qianlong devoted himself to painting and was a great patron of the arts. Following the example of his grandfather, he commissioned ambitious written works. The most significant, the *Siku Quanshu* (Library of the Four Treasures) is an anthology comprising all Chinese writings known at the time. From 1772 onwards, 360 scholars compiled and edited the works, classifying the 36,000 books (79,582 volumes) into four categories: Confucian classics, history, philosophy and literature. Then 15,000 scribes were responsible for recopying these texts, completing the seven copies of the *Siku Quanshu* in 1782.

To an even greater extent than his predecessors, the ruler had a love of beautiful objects. He regularly visited the palace workshops, some of which were housed in the Pavilion of the Old Moon (Guyue xuan), in the southern part of the Forbidden City. He also devoted a great amount of time to his collections, continuously seeking to add to them. From 1743, therefore, he established several specialized catalogues. The most significant, devoted to the arts of the brush, was completed in 1744 and listed 10,000 paintings and works of calligraphy. The sovereign was particularly fond of carved jade. In 1741 alone, 376 items bearing his seal were added to the collection.

Following the example of his grandfather Kangxi, Qianlong carried out six tours of inspection in the south. Enchanted by the idyllic landscapes of southern China, he installed replicas of the imposing sites and celebrated monuments of Jiangsu and Zhejiang in the gardens of his summer palaces.

Producing his first works of calligraphy at the age of six, Hongli, the future Qianlong, displayed a precocious taste for study. At twelve, his knowledge of the classics astounded Kangxi, his grandfather. His studies were supervised by learned scholars from the Hanlin Academy.

Qianlong prided himself on his artistic and literary gifts. As the highest tribute, he sometimes placed his own signature on the works of his entourage. His poetry (above), paintings (opposite, *Three Friends of Winter*) and calligraphy provide evidence of true talent but also academicism.

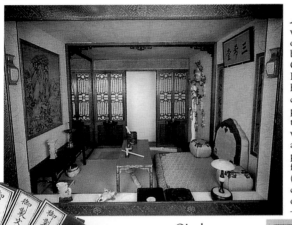

A series of small rooms, in the western part of the Hall of Mental Cultivation, bear witness to Qianlong's refined taste. In 1746 the emperor had an elegant and comfortable office prepared, the room of the Three Rarities (left), where he often retired to admire and study three pieces of calligraphy from the Jin period (265–420), which he considered the jewels of his collection.

Qianlong was even more fervently opposed than Yongzheng had been to the activities of the Catholic missions in China and, in 1742, he purely and simply banned them. Nevertheless, like Kangxi, he called on the Jesuits' scientific knowledge and artistic talents.

The most celebrated of his 'advisors' was Father Giuseppe Castiglione. Appreciating the Milanese's gifts both as a painter and an architect, as well as those of the Frenchman Michel Benoist, a mathematician and astronomer skilled in hydraulics, he entrusted them with the plans of the western palaces built to the north-east of his Summer Palace at Yuanmingyuan (Garden of Perfection and Brightness) between 1747 and 1759.

Father Castiglione, who remained at court until his death in 1766, was to end his career as Chief Minister for the Administration of the Secondary Imperial Residences.

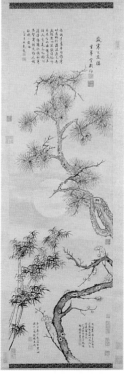

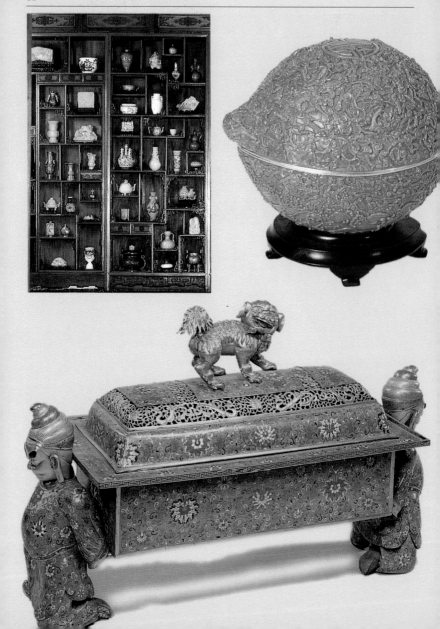

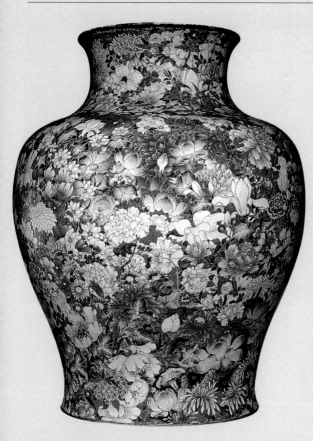

The palace workshops, the imperial factories in southern China and Beijing, as well as the tributes paid by the provinces provided the court with precious objects. In the imperial apartments, such as the Study of Fresh Fragrance (Shufang zhai), the rare objects were arranged on display shelves (opposite top left). They often echo earlier forms, like this brazier (opposite bottom) inspired by a piece from the Ming period, or play on ambiguity in the materials adopted, like this coral box that imitates lacquer (opposite top right). Porcelain dating from the reigns of Yongzheng and Qianlong is often called *yangcai* ('Western colours'), known in the West as *famille rose*. Some pieces, such as this 'hundred flowers' vase (left), are remarkable technical achievements. The boxes shown below bear a delicate floral pattern in repoussé.

The crisis at the end of the reign

The last years of Qianlong's reign were nevertheless marred by an economic crisis that developed around 1770. As the population continued to increase more rapidly than agricultural resources, the Treasury was depleted by the emperor's fanciful architectural ideas, the extravagant lifestyle of the court, and by the insatiable demands of the machinery of state and military expeditions. In order to rectify the situation, the government reformed the tax system, curbing the prosperity of those who lived in the countryside and forcing numerous small landowners into debt. Peasant revolts broke out in many parts of the empire.

At the same time, the administration was blighted by rampant corruption. In 1775 the emperor himself granted an inordinate amount of power to an arrogantly

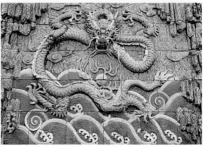

The decoration of the screen wall protecting the Palace of Peaceful Longevity from evil spirits (above) imitates that of the famous Nine Dragons Screen (Jiulong bi), a polychrome ceramic masterpiece dating from 1417.

handsome young Manchu general named Heshen (1750–99). This favourite was awarded the highest offices and placed his own followers in key positions. His misappropriation of funds and the influence he exerted over the emperor and the administration only made the absolutist regime worse. After Qianlong's death, he was ordered to commit suicide.

Although restoration work and alterations were carried out in the Forbidden City throughout Qianlong's reign, one place in particular bears the emperor's mark. Refusing, out of respect for his grandfather, to remain in power for as long as he had, Qianlong planned to retire to the Palace of Peaceful Longevity (Ningshou gong) [22] at the end of his fifty-nine-year reign. The residence, which had been built in the north-east corner of the Inner Court in 1689, was magnificently restructured between 1772 and 1776 to satisfy his taste. After abdicating at the age of eighty-four in favour of his son Jiaqing (1796–1820), he was happy to remain in this palace and secretly continued to be involved in some affairs of state until his death.

The daily life of the Manchu emperors

The Forbidden City was, in fact, merely the winter residence of the Manchu emperors. They resided here from November to February – the busiest period as regards official ceremonies – and divided the rest of their time between their summer palaces and their various other homes. A large household of servants was attached to each of the imperial residences.

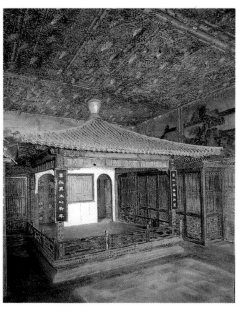

In the garden of the Palace of Peaceful Longevity, rockeries, artificial hills concealing grottoes and pavilions conjured up sites in southern China of which the emperor was particularly fond. A bamboo forest is painted in *trompe l'œil* on the walls and a flower-covered trellis on the ceiling of the little theatre built at one end of the garden (above).

After the poetry competitions for the spring festival, the scholars let their wine goblets float along the canal beneath the Xishang pavilion (top left).

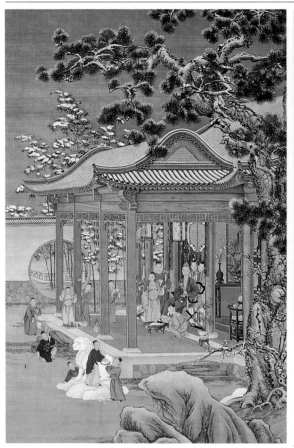

This large painting (left) depicts Qianlong in ancient Chinese costume, surrounded by his sons and nephews for the *Joyous Eve of the New Year*. The youngest are playing in a carefree manner, while the older boys are shown with a deferential attitude. The work, painted in 1738 by Father Castiglione and other artists in the imperial workshops, is a brilliant synthesis of Chinese and Western pictorial traditions.

Towards the end of his life, Kangxi built the Hall of Mental Cultivation (Yangxin dian) [16] to the west of the courtyard of the Palace of Heavenly Purity. He was unable to make the most of it before he died, but his son Yongzheng and his successors established their apartments there.

The ruler awoke very early, at about 3 o'clock. After an initial session of work and a light meal, consultation with ministers and the meeting of the council took place. Until about 11 o'clock, the Son of Heaven spent

Qianlong died in this room in the eastern wing of the Hall of Mental Cultivation in 1799 (left). The decoration, changed by the last three Qing emperors, bears witness to the improvements carried out in the Forbidden City during the 19th century. The dark wooden furniture is set off by the light-coloured walls, hung with damask silk. Its lines occasionally evoke the furniture of the late Ming period, but the finely carved interlacing gives a feeling of decorative abundance. On the wall, carved and inlaid panels, sometimes covered with kingfisher feathers, alternate with decorative paintings and calligraphy. The floor was formerly covered with carpets.

time giving audiences and receiving officials. He then had lunch alone at his table, as etiquette demanded, picking at the innumerable dishes of food placed before him. The Forbidden City's vast kitchens were situated far away and the food often arrived cold. As a refined gourmet, Qianlong had his own personal kitchen set up close to his apartments, south of the Hall of Mental Cultivation (Yangxin dian).

After a walk and various leisure activities, the afternoon was filled with meetings and the annotation of administrative reports until 5 o'clock. After dinner, Kangxi liked to discuss a wide range of subjects with his chosen guests. The

Traditionally, when the emperor died, all his clothes were burnt, but the economic crisis in the 19th century led to this custom being partially abandoned. Thus Qianlong's successors made do with this cap by altering its inside.

Jesuits were often summoned to join these academic discussions. The emperor retired to bed early.

Empresses and concubines

Behind the Hall of Mental Cultivation, the Six West Palaces (Xiliu gong) [18] are arranged in a grid pattern. They are echoed on the other side of the ceremonial palaces of the Inner Court by the Six East Palaces

In the evening, all the men left the palace, leaving the emperor, his wives and the eunuchs. Only a pavilion close to the Hall of Mental Cultivation was manned.

(Dongliu gong) [21]. These twelve residences set aside for the emperor's wives contained twenty-two rooms arranged around two courtyards – reception rooms in the first and apartments in the second. Flower arrangements, paintings and other decorative objects provided each with its own particular atmosphere.

Behind these two groups of palaces were the buildings reserved for the infant princes. The little boys were subsequently housed in small green-roofed pavilions purposely built for them to the south-east of the enclosure.

The empress dowager, the most eminent woman in the imperial family, did not live in these quarters with their relatively modest proportions, but in the Palace of Benevolent Tranquillity (Cining gong) [26] to the west of the Hall of Mental Cultivation.

While she often took part in the affairs of state, it was her daughter-in-law, the empress, who governed the affairs of the Inner Court. She was followed in the hierarchy of this gynaeceum by the secondary wives and the imperial concubines. Wishing to distinguish himself from the Ming rulers, who were considered debauched, Kangxi reduced their ranks from twelve to seven and limited the number of women entitled to belong to the first four ranks. The size of their apartments and the number of servants they had, the colour and quality of their ceremonial dress depended on each one's position in this hierarchy.

The number of women varied considerably according to the period. Emperor Kangxi had three empresses and nineteen concubines; Qianlong, two official wives and twenty-nine concubines. In the 19th century the unfortunate Guangxu, Cixi's puppet, had only one empress and two concubines.

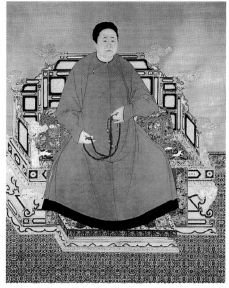

Empress Xiaozhuang (1613–87) was the daughter of a Mongol prince. In 1625 she entered Prince Abahai's gynaeceum as a concubine and in 1638 gave birth to little Fulin, the future Shunzhi. In 1644 China's new ruler granted her the title of Revered Empress-Mother. She took part in the affairs of state during her son's reign and until her grandson Kangxi came of age. In the portrait above, painted towards the end of her life, she is shown wearing a very simple costume and holding a rosary in her hand, in the manner of a Buddhist nun. She died in the Forbidden City.

All these women came from the best Manchu, Mongol or Chinese families and entered the palace after rigorous selection. Only a young Manchu could reach the rank of empress, though she was first obliged to sleep with the emperor.

The names of the imperial wives and concubines were engraved on jade tablets, kept in the ruler's apartments. In the evening, the emperor simply had to turn over the plaque bearing the name of the girl(s) with whom he wished to spend the night. A eunuch was sent to the one who had been chosen and ensured that she was stripped naked (so that she could not conceal a weapon), bathed and depilated before carrying her to his master's chamber wrapped in a cloak.

Some women waited months, sometimes years before being honoured by the Son of Heaven. Their 'advancement' in the gynaeceum depended on the number of nights spent in the imperial bed – the eunuchs kept a precise record of these. Likewise, the birth of a son was a source of great prestige for the mother, who gained immediate promotion.

These highly educated women, cut off from their own families, filled their time by devoting themselves to embroidery or the art of sewing, but also to skilled intrigue. Only sons born of Manchu mothers could

aspire to ascending the throne one day. Since power was not transmitted to the firstborn, the pretenders and their mothers indulged in shady schemes designed to influence the ruler's choice in their favour, and certain successions resulted in violent settling of scores.

On the death of the sovereign, his wives and concubines retired to a vast complex, situated to the west of the

Unlike their Chinese counterparts, Manchu women did not bind their feet, but these shoes with their central heel (opposite below) gave them the same hesitant gait, considered highly seductive.

Gold thread, pearls and kingfisher feathers conferred great elegance on female headgear (below).

enclosure, in the Palace of Benevolent Tranquillity and in two other outer palaces to the west.

Relationships within the imperial family remained extremely formal. It was only with his sons that the emperor displayed any familiarity. The young princes, entrusted to the most

Qing ceremonial costumes were based on those of the Ming, but adapted to Manchu traditions. Less full, the robe (centre) provided greater ease of movement. The narrower sleeves were trimmed with 'horse hoof' cuffs.

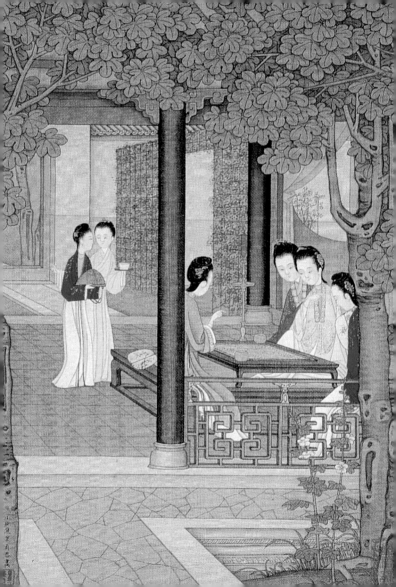

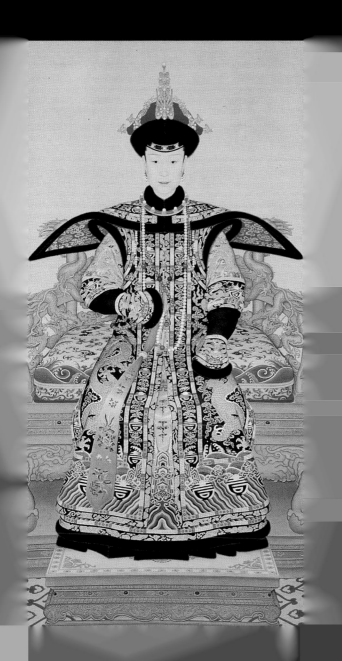

learned mandarins, studied Chinese, Manchu and Mongol literature so as to reach adulthood equipped with a sound knowledge of their culture. Training in the handling of weapons completed their education.

The eunuchs

In China, the custom of castrating prisoners of war and using them as servants in the palace dated to the Zhou dynasty (12th to 3rd century BC), but the Han emperor Guangwu (AD 25–57), fearing for the honour of his wives and concubines, was the first to insist that all the male servants in the palace were to be become eunuchs. Soon invested with official roles, these low-born servants did not take long to replace scholars in the rulers' immediate entourage. Having become the incontrovertible intermediaries between the prince and his subjects, the most

influential among them were able to make money from their services and amass huge fortunes, and they sometimes intervened in the affairs of state, particularly during the Tang (618–907) and Ming (1368–1644) periods.

Under the Ming, the chief eunuchs of the palace, entrusted with watching over the emperor and his family, ended up by taking the reins of government in their own hands. They decreed laws, appointed and dismissed ministers and officials. They also controlled the finances and their misappropriation of funds considerably weakened the Treasury.

The first Manchu emperor therefore ensured that the great eunuchs were excluded from the affairs of state, but Qianlong restored them to office and their nobiliary

The eunuchs were responsible for drawing water from the Forbidden City's eighty wells. They also had to ensure that the large bronze urns (left), placed everywhere to put out fires, were always full and that their contents never froze. In the winter, they maintained the furnaces installed below some of the courtyards which heated the floors of neighbouring rooms by means of ducts. Braziers were used to provide extra heating in the apartments, but many buildings, notably the ceremonial halls, were not heated.

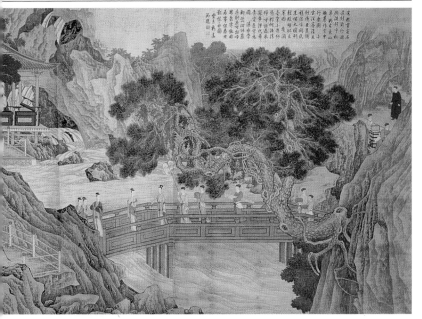

titles. Once again, their love of wealth and power contributed to sealing the fate of the imperial regime.

The number of eunuchs working in the Forbidden City varied greatly according to the period. The Ming court is supposed to have employed over 20,000 – but this figure is undoubtedly an exaggeration. Kangxi reduced the number to 9000, Qianlong to fewer than 3000. When the last dynasty fell, they numbered no more than 1500.

For all these men, the degrading condition of being a eunuch was their only hope of escaping poverty and they either volunteered or were sold by their parents or by child-traffickers. The operation was usually carried out by official castrators from the Bi and Lin families who officiated in Beijing until 1900. Armed with a certificate testifying to their castration, the eunuchs then presented themselves at court, before a jury that met every three months. After having learnt the rudiments of etiquette, they were assigned to one of the many departments responsible for the running of the palace.

In 1751, at the time of his second journey in the south, Qianlong was presented with an album containing subjects with a religious theme by Jin Tingbao, a painter from Wucheng, in Zhejiang. Captivated, the emperor invited the artist to his court. Jin Tingbao joined the imperial workshop and died in 1767. The scene above takes place in a conventional pastoral landscape. The emperor is lounging against the balustrade of a pavilion, while the eunuchs accompanying his wives carry the items needed for this country outing.

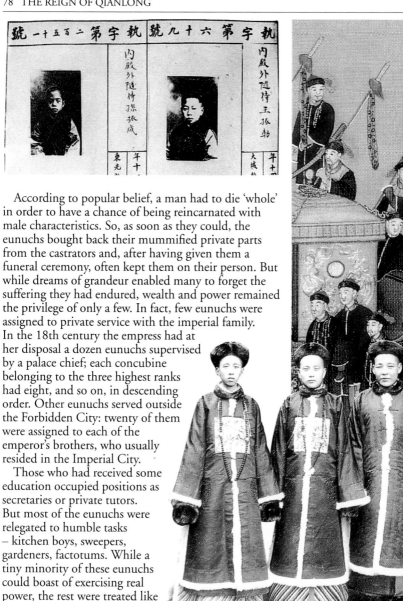

According to popular belief, a man had to die 'whole' in order to have a chance of being reincarnated with male characteristics. So, as soon as they could, the eunuchs bought back their mummified private parts from the castrators and, after having given them a funeral ceremony, often kept them on their person. But while dreams of grandeur enabled many to forget the suffering they had endured, wealth and power remained the privilege of only a few. In fact, few eunuchs were assigned to private service with the imperial family. In the 18th century the empress had at her disposal a dozen eunuchs supervised by a palace chief; each concubine belonging to the three highest ranks had eight, and so on, in descending order. Other eunuchs served outside the Forbidden City: twenty of them were assigned to each of the emperor's brothers, who usually resided in the Imperial City.

Those who had received some education occupied positions as secretaries or private tutors. But most of the eunuchs were relegated to humble tasks – kitchen boys, sweepers, gardeners, factotums. While a tiny minority of these eunuchs could boast of exercising real power, the rest were treated like

Eunuchs (left and below left) received wages proportional to their rank, and were paid in silver or copper coins and rations of rice, to which bonuses were added on annual festivals or special occasions (weddings, the birth of a prince...). Although most lived modestly, occupying rooms hidden in the recesses of the Forbidden City, the most powerful and wealthy of the eunuchs built themselves patrician dwellings outside the palace where they maintained a fictitious family. They acquired land in the region where they were born or even invested in business and property in Beijing. When they were too old or too ill to work, the eunuchs could leave the palace. Many ended their days in modest circumstances. The wealthiest retired to the Buddhist monasteries to which they had made substantial donations. A cemetery was established for the imperial eunuchs in the western outskirts of Beijing in 1735.

Far left: castration certificates of young eunuchs.

slaves. Often humiliated, beaten for the merest trifle, they could be put to death at the simple whim of their master.

The most important eunuchs gradually reached the ranks of civil servants. In 1678, for the first time, four of them were appointed as officials to the fifth rank and

two to the sixth. It was not until the reign of Guangxu (1875–1908) that they gained access to the highest ranks. Li Lianying, Cixi's favourite eunuch, was promoted to official of second rank.

The eunuchs took revenge for the contempt shown to them because of their physical condition, for the frustrations of all descriptions and for the ill-treatment they had to endure by enriching themselves at their masters' expense and, if they wielded a certain amount of power, by ensuring that they were paid for even the smallest service. In the 19th century corruption amongst the eunuchs increased as imperial power weakened. The Empress Dowager Cixi exploited them as a means of exerting complete control over the palace and her family.

Many eunuchs maintained amorous friendships with maidservants in the palace, despite repeated bans aimed at separating these two categories of servant.

Palace maids

The palace employed a number of young maidservants. During the Ming dynasty, they numbered 9000. In its darkest hour, the dynasty even had

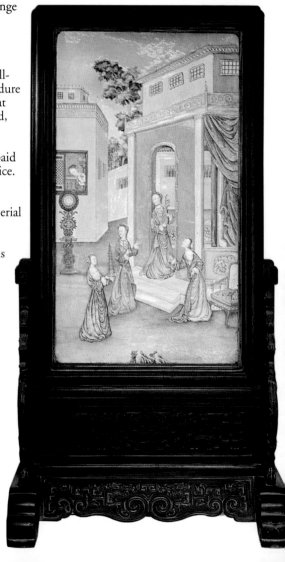

This screen shows the fashion for Western subjects at the end of the 18th century.

difficulty in feeding and maintaining all these palace maids (*gongnü*). The Manchus not only reduced their number but also their freedom. In 1710 there were almost 500, while, by the end of the 19th century, there were no more than 200.

The date of the triennial competition held to recruit these maidservants was announced three months in advance. The thirteen-year-old girls who came forward were usually from families enslaved by the Manchus. Any family ties with a eunuch, however distant, excluded them from entering the palace.

Those chosen underwent a year's initiation into the mysteries of etiquette before being allocated to one of the many departments on the basis of their skills. The most fortunate were assigned to the service of the

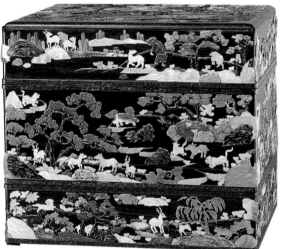

The protocol in force in the Forbidden City even applied to the crockery, which was divided into a hierarchy based on materials (gold, jade, silver, porcelain, enamel) and colour. Thus the emperor and empress had the exclusive right to use gold and 'radiant yellow' porcelain. The plates and bowls meant for other members of the imperial family were also distinguished by their colour according to rank. Under the reign of Daoguang (1821–50), the kitchens of the Forbidden City contained more than 3000 pieces of gold and silver plate. Some gold pieces (below) could weigh as much as 140 kg (308 lbs), while silver pieces weighed up to 1250 kg (2756 lbs).

Boxes with fitted compartments (left), usually in pairs, were used to carry food. Refreshments were often offered to people one wished to honour.

emperor's close relations. During the reign of Kangxi, the empress dowager's household had twelve maidservants, the empress' household had ten, and those of the concubines of first rank had eight, and so on in descending order. They could

also be engaged by
a Manchu prince.
These female servants
were responsible in
particular for looking
after jewelry and
clothing (sewing,
embroidery, and the
wash house situated
at Anletang, near
Beihei Park, to
the north-west of
the Forbidden City).

The Qing re-established the use of embroidered squares to indicate the grade of the officials recruited by competition. The crane on the embroidered square on the left was the insignia of civilian mandarins of first rank.

The maidservants could also capture the ruler's interest and rise to the coveted position of concubine, as in the case of Nala, who, after giving birth to Prince Yiwei, was elevated to this rank by Emperor Daoguang.

Most of them, however, left the palace with a few savings after four or five years in service. The posts they had occupied at court, however modest, were considered highly prestigious in the eyes of everyone else and they had no trouble in finding a husband, but once they had left the Forbidden City, they could never return.

The 'external' employees of the palace

At the end of the 18th century, when the Qing dynasty was at its height, the number of people residing within the Forbidden City is estimated to have been approximately 9000. However, the city-palace also made use of several categories of 'external' employees, with a very different status.

The administrative
buildings of the Outer
Court, including an
important translation
service, employed
numerous officials of
all ranks, who resided
outside the palace.

The various imperial
domains and the
sovereign's personal
fortune were managed

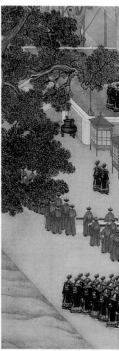

The *qilin* decorating the square on the left, dating from the reign of Daoguang (1821–50), was a legendary beast, of good omen, used to distinguish military mandarins of first rank.

by the Imperial Household Department (Neiwufu). The Manchus held hereditary positions in this particular administration. Unlike the eunuchs and maidservants in the Forbidden City, they actually increased in number, from 402 in 1602 to 3000 at the beginning of the 20th century.

Under Qianlong, the Neiwufu's budget was equivalent to a quarter of that of the state. It was independent and

During the second lunar month, the Son of Heaven made a sacrifice at the Altar of the God of Agriculture, to the west of the Temple of Heaven. This altar, built by the Ming emperor Jiajing (1522–66), was restored by the

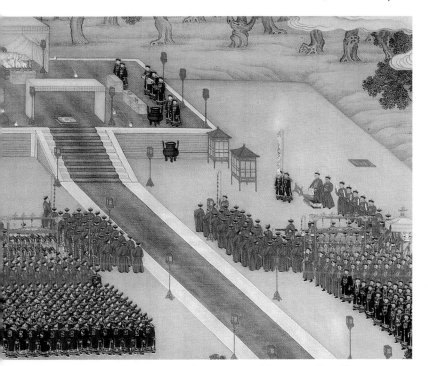

had its own resources, even contributing part of them to the Treasury. From 1857, however, as the economic crisis spread, the process was reversed.

In addition to these employees, there were the guards – totalling almost one thousand men – who protected the Forbidden City and the domestic servants (who carried out the lowliest tasks), all of whom were housed in annexes.

Qing. The emperor carried out this agrarian ritual surrounded by princes and high-ranking officials. Above: mandarins in blue costumes, dancers and the orchestra, in red robes, await his arrival.

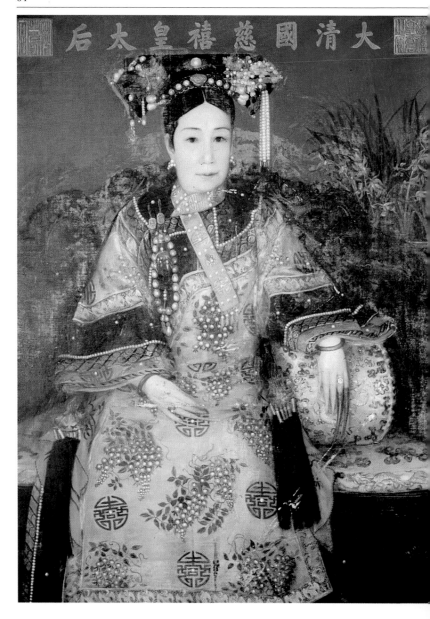

大清國慈禧皇太后



The end of the 19th century witnessed the beginning of the Manchu dynasty's decline. Neither Qianlong's appointed successors nor the Empress Dowager Cixi succeeded in carrying out the reforms necessary to halt the crisis at home or to stand up to foreign powers. The Qing brought down an ancient empire, of which the Forbidden City was the emblem and focal point.

CHAPTER 4

TWILIGHT OF A DYNASTY

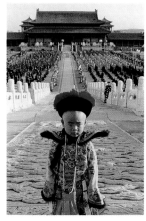

Under the name of Cixi, Yehonala (1835–1908), the daughter of a Manchu magistrate from Shaanxi (opposite), reigned over China from 1862 until her death. Puyi, the last emperor of China (right, a still from Bertolucci's film), succeeded to the throne on 2 December 1908, at the age of two, and was forced to abdicate in 1912.

The death throes of the Qing dynasty

After the abdication of Qianlong, the dynasty was only to bring emperors who were weak or mediocre to power, and subsequently children manipulated by the Empress Dowager Cixi. Given the autocratic nature of the regime, the slightest weakening of imperial power could only result in serious problems. The absolute rule of an ultra-conservative clan, an increase in the number of petty regulations holding the initiatives of provincial officials in check, and the enormous superiority complex of the elite were all obstacles to any desire for reform.

The weakness of the Chinese currency, which was based on silver, a metal that continued to

By increasing its imports of opium from India, the East India Company was to enable Great Britain to be the beneficiary in its trade with the Middle Empire. The opium was taken in the form of small pellets which were slowly burnt in a little receptacle fitted to the end of a long pipe (left). It produced a state of relaxed euphoria after the user was used to it. The caricature below was published at the height of the Opium Wars in 1842.

depreciate in relation to currency linked to gold, and the increasingly active resistance of the Chinese to Manchu domination only speeded up an irreversible process of decline.

Moreover, the Qing, who like their predecessors focused their policy on central Asia, did not perceive the growing threat constituted by European powers. In 1793 Qianlong had assured Lord Macartney, the British

ambassador, that the Middle Empire had no need for 'barbarian' products as it received all it required from tributary nations. Under the reign of Jiaqing (1796–1820), only the port of Guangzhou (Canton) was open to foreign ships and trade was subject to strict regulations. Since China refused to open up to them for commerce, Westerners took its ports by force.

The Opium Wars and the confrontation with the West

To compensate for their acquisition of Chinese products, the British started to import contraband opium from India, despite repeated bans by the local authorities who saw entire sections of society destroyed by this scourge. In 1839 the governor of Guangzhou ordered 20,000 boxes of opium that had been seized to be publicly burnt, thus triggering off the first Opium War (1839–42). Under the terms of the Treaty of Nankin (Nanjing), Emperor Daoguang had to pay the British heavy compensation, cede Hong Kong to them, open five Chinese ports to international trade and allow the powers to build 'legations' enjoying extraterritorial rights to the south-east of the Forbidden City. The court was content to allow the population to bear the cost of the compensation, thereby increasing social unrest.

During the reign of Xianfeng (1851–61) rebellions flared up in all four corners of the empire. The most significant was the Taiping ('Great Peace') Rebellion (1850–64), a messianic movement whose aim was to overthrow the Manchu and to establish an egalitarian society, which was to devastate a large part of southern China. The Western powers exploited the weakness of the regime, using it to press for further advantages and to start the second Opium War in 1856. The Treaty of Tianjin of 1858 opened

In 1813, with the help of his followers, Prince Minning managed to overcome the conspirators who were trying to gain control over his father, Emperor Jiaqing. The strength and courage displayed during this attempted coup d'etat soon evaporated after he ascended the throne under the name of Daoguang. Entirely lacking in calibre, his reign was to prove disastrous. Daoguang is shown (above) in everyday clothes, holding a book entitled *The Principle Events of Ancient Chinese History*. This painting was executed in 1849, when the emperor was sixty-nine.

up other ports to them.
In 1860 a Franco-British expeditionary force marched on Beijing to avenge the assassination of European plenipotentiaries, looting and setting on fire the summer palaces of Yiheyuan and Yuanmingyuan, close to the capital. China was subsequently opened up to foreigners definitively by further 'unequal treaties'.

Empress Dowager Cixi

On the death of Xianfeng, his young son Tongzhi (1862–74) ascended the throne, but until 1873 the regency was guaranteed by the dowager empresses, the insignificant Cian and Cixi, a many-faceted character who was to dominate political life from 1875 until her death in 1908.

Having entered the Forbidden City at seventeen as a concubine of fifth rank, this Manchu beauty, who had been given a perfect education and who was endowed with a remarkably lively mind, rose in the hierarchy of the gynaeceum after having borne Xianfeng a son called Tongzhi in 1856. Upon the death of Tongzhi, she placed Guangxu (1875–1908), her four-year old nephew, on the throne and once again assumed the regency.

In an empire in which women theoretically played no part in public affairs, Cixi was to reign over China with absolute power for forty-eight years. In view of the era and the circle into which she was born, she was a remarkable woman, but she was cut off in her luxurious palaces and became divorced from the realities of the

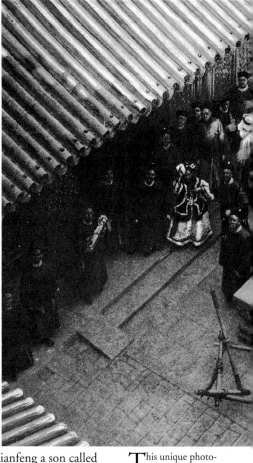

This unique photograph of the Empress Dowager Cixi was taken on 29 April 1902. Before entering a small temple dedicated to the titular gods of Beijing, the empress dowager greets the women gathered on the ramparts of the Tartar city.

world. Blinded by her thirst for power, advocating the defence of the most traditional Chinese values in the face of the greed of the colonial powers, she was unable to create any solutions to the serious social and economic problems burdening China.

Drawing on the lessons of the Taiping Rebellion, she supported for a while the Yangwu Movement ('Management in the Western style'), which advocated the 'self-strengthening' of China (1860–85). A programme of industrialization was undertaken, with the creation of arsenals, naval shipyards, mining companies, railways and textile factories, whilst the restoration of the Confucian administration was a moderate success.

The disastrous defeat at the hands of the Japanese in 1894 and the humiliating Treaty of Shimonoseki signed in 1895 highlighted the inadequacy of these efforts. Invested with full power upon coming of age, Guangxu decided in 1898 to support the Reform Movement led by Kang Youwei (1858–1927) – author of a biography of Peter the Great – to speed up the modernization of the economy and to extend it to the country's institutions, drawing inspiration from Japanese and Russian models. A certain number of edicts were passed, but, at the end of the period from June to September 1898 (the 'Hundred-Day Reform'), Cixi once again took control of the situation with the support of the ultra-conservatives. The reformers were mercilessly hunted down and the edicts repealed. Guangxu was placed under house arrest until the end of his days and the empress dowager reigned in his name.

The Western press mocked Cixi, as this caricature (below) illustrates. It was published just before the Boxers besieged the foreign legations in Beijing in 1900.

In the 19th century the Eastern Warm Chamber in the Hall of Mental Cultivation (bottom) served as a council chamber. Hidden behind the yellow screen, Cixi gave the emperor her instructions.

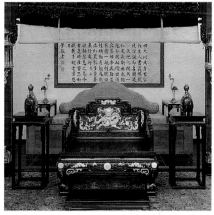

The Boxer Rebellion

At the same time, Japan's territorial gains (the annexation of Taiwan and the Pescadores) drove the Western powers to demand new concessions from the Qing (the Break up movement), thus affirming their economic and military ascendancy over China. This slow dismembering of the empire and the harassment accompanying it could only arouse hatred for the 'Long Noses' and compromise all policies for Western-style modernization.

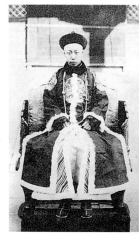

Marshal Yuan Shikai, who deposed Puyi in 1912 and reigned supreme over Beijing, died in June 1916. On 1 July 1917 General Zhang Xun, who controlled Jiangsu and the region of Tianjin, entered the capital and restored Puyi (left) to the throne. Eleven days later, a plane flown by a republican officer dropped three small bombs on the Forbidden City. The day after, Zhang Xun's troops withdrew, bringing the fleeting restoration of the monarchy to an end.

The worsening of poverty among the peasants, the unemployment provoked by the progress of steam navigation and the railways fed a vast movement for popular revolt from 1898. The Yihequan, militia 'of justice and concord', attacked foreign interests, missionaries and Chinese converts to Christianity – compared in popular imagery to pigs.

In 1900 the Yihequan – known by the West as 'Boxers' as they took part in martial exercises called 'Harmony Fists' – entered Beijing. For fifty-five days, with the tacit support of the court, they laid siege to the legations' compound where the foreigners had taken refuge. An international expeditionary force sent to the capital crushed the rebellion, indulging in looting and killing, while the empress dowager sought refuge in Xi'an. The Manchu regime, weakened still further, was forced once again to pay heavy war compensation to the Western powers and to grant them new privileges.

Between 1901 and 1903 the court itself pressed ahead with the reforms advocated by Kang Youwei, although they came too late. The Manchus were accused increasingly

openly of having sold China to foreigners and, in 1907, the Chinese Nationalist Party, the *Guomindang*, was founded by Sun Yat-sen (1866–1925).

Following the death of Cixi, in 1908, a two-year-old child, Emperor Xuantong (1909–12), better known as Puyi, succeeded to the throne. However, the Qing dynasty was to be swept aside by the 'revolution'. In February 1912 the young Puyi was forced to abdicate by Marshal Yuan Shikai, who proclaimed himself president of the republic. The deposed emperor continued to reside in the Forbidden City until 1924, but the long reign of the Sons of Heaven on the Dragon throne had come to an end years before.

In August 1900, after having seized Tianjin, the Allied forces (consisting of British, American, Russian, German, Japanese, French, Italian and Austrian troops) liberated Beijing, where the Boxers had besieged the foreign legations since June. The Japanese were the first to enter the capital. The French camped in Beihai Park (below left), north-west of the Forbidden City, and in the Temple of Imperial Longevity, north-east of Coal Hill. Bloody repression was to follow (below).

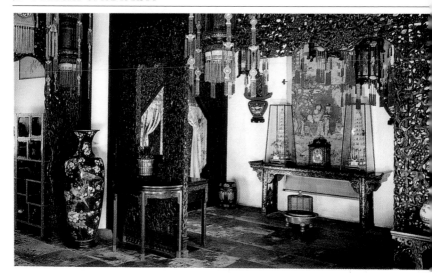

The final alterations to the Forbidden City

Many buildings in the Forbidden City bear the mark of Cixi, just as the summer palace of Yiheyuan does. It was rebuilt by Cixi in 1888 with funds intended for the modernization of the navy.

In 1861, upon the death of Emperor Xianfeng, her noble husband, the empress dowager refused to retire to one of the outer West Palaces as tradition demanded, preferring instead to live in the Palace of Eternal Spring (Changchun gong). In 1885, the year of her fiftieth birthday, she had the Palace of Concentrated Beauty (Chuxiu gong), another of the Six West Palaces, entirely refurbished. The renovation of this pavilion and of two other buildings in the palace was to cost 630,000 taels of silver.

In the courtyard of the Palace of Concentrated Beauty, bronze dragons and deer serve as symbols of good luck, while laudatory inscriptions written by learned courtesans cover the walls. The interior is extremely elegant, particularly the beautifully proportioned central hall where Cixi sat on her ceremonial throne every morning to receive the homage of her visitors. The presents she received on her fiftieth birthday – notably

The Palace of Concentrated Beauty (above) consisted of several rooms distributed on either side of an audience chamber. One of these side rooms served as Cixi's bedchamber.

two enormous peaches, symbol of longevity, in enamelled sections – are tastefully arranged in the room. The 'Venerable Grandmother', who nurtured a real passion for the Beijing opera, had had a little theatre installed in one wing of the Palace of Concentrated Beauty. A remarkable opera company, consisting of 384 eunuch musicians and actors, was attached to the court, and the Forbidden City contained a dozen theatres.

Cixi lived in this palace for ten years, waited on by 180 eunuchs and maidservants. On her sixtieth birthday she moved into the Palace of Peaceful Longevity, in the north-east corner of the Forbidden City, to which Qianlong had retired following his abdication.

To the west of the Imperial Garden, Qianlong built a two-storey theatre, situated in the courtyard of the Study of Fresh Fragrance (below), and a banqueting and concert hall. It was here that the imperial family celebrated the Spring Festival. The theatre housed smaller gatherings than those held in the Pavilion of

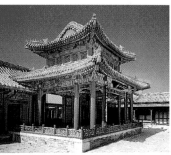

Pleasant Sounds at the other end of the palace.

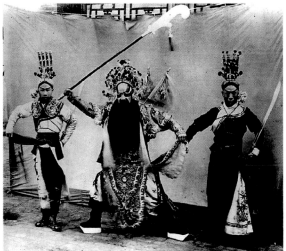

The Beijing opera (left) is a unique theatrical genre combining singing, recitation and acrobatic dance. The costumes, make-up and gestures are strictly codified. An 'internal troupe', composed of eunuchs, and an 'external troupe', whose actors were selected by the Office of the Theatre at the court, performed regularly in the palace, in addition to the celebrated troupes that were frequently invited.

Although the Palace of Concentrated Beauty, stripped of its precious carpets and much of its upholstery, does not entirely do justice to the empress dowager's tastes, an overabundance of ornamentation and sense of luxury can still be perceived. Neither the furniture nor the porcelain, however, possess the technical brilliance and flair of similar pieces dating from the 17th and 18th centuries.

From palace to museum

In 1900, due to lack of funds, entire sections of the palace were left to fall into disrepair, as those Westerners who entered the city after the Boxer Rebellion were to note. Following the fall of the empire, the young Puyi retired to the Hall of Mental Cultivation, in the northeast corner of the Forbidden City, and was to remain there until his departure for Tianjin. On 10 October 1925 the complex was officially transformed into a museum.

Since the 15th century China has lived through many upheavals, but the palatial complex built by Yongle has withstood them with very little damage. Spared during the Sino-Japanese War (1936–45), the Forbidden City was protected as a national monument during the Cultural Revolution (1965–8). Since 1987 this Old Palace (Gu gong), one of the largest museums in the world, has been designated as a world heritage site by UNESCO.

Despite a substantial part of the imperial collections being transferred to Taiwan, the Forbidden City still houses almost one million art objects. The great ceremonial halls were carefully restored in the early 1980s, as were some palaces in the private area. Some of these apartments remain exactly as they were in the 19th century, others are earlier reconstructions.

Other buildings take it in turns to display the art collections and house temporary exhibitions. The most precious items are exhibited in the Palace of Peaceful Longevity, which has been transformed into a veritable 'treasury'. The temples and adjoining pavilions are due to be restored within the next few years.

Every year, the Old Palace receives between six to eight million visitors, the majority of whom are Chinese.

In 1928 Beijing was replaced as capital by Nanjing. The Forbidden City, now abandoned, gradually fell into decay (below). The Gate of Heavenly Purity viewed from the northern terrace of the Hall of Protecting Harmony is visible on the right.

Just as Emperor Yongle, its creator, would undoubtedly have wished, it remains the symbol of an age-old China.

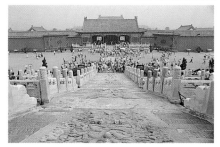

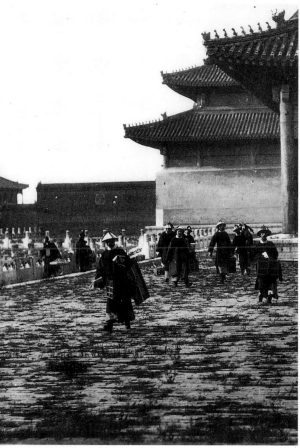

In *Twilight in the Forbidden City* (1934), Reginald F. Johnston (1874–1938), Puyi's Scottish tutor, describes the situation at the time of his arrival in 1919: 'In the heart of Peking were two adjacent palaces. In that which still retained the distinction of being the "Forbidden City" dwelt a titular monarch; in the other resided the chief executive of the republic. In the latter was a presidential chair occupied by one who exercised the powers of an emperor without the name; in the former was a throne on which sat one who was an emperor in name alone. He who ruled the vast realm of China was called a president; he whose rule did not extend an inch beyond his palace walls was called an emperor....'

Above: visitors in front of the Gate of Heavenly Purity. Overleaf: the enthronement of Puyi.

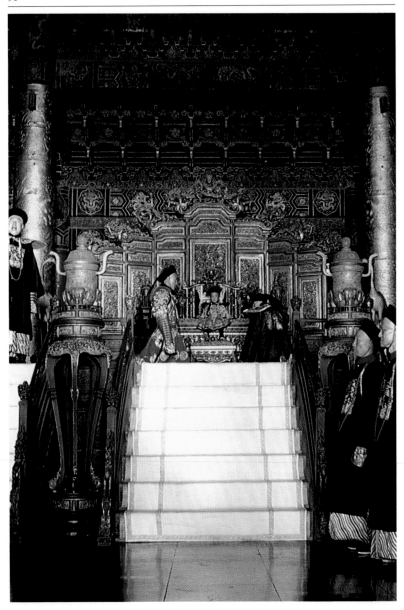

DOCUMENTS

'On the opposite side of this miniature lake stood
the imperial apartments, entered by none save members
of the imperial family. If you can imagine fairies to be the
size of ordinary mortals, this then was fairyland.
Never have I beheld a scene which realized one's ideas of
an enchanted land before.'

Rev. R. J. L. McGhee
*How We Got to Pekin: A Narrative
of the Campaign in China of 1860*, 1862

'Barbarians'

Following in the footsteps of Marco Polo (below), European missionaries and diplomats made the journey to China. They brought back tales and recollections of a country that, for a long time, seemed to be a separate planet.

In the palace of the Great Khan

Between 1271 and 1295, Marco Polo travelled all over Asia and became acquainted with the Mongol emperor Kubilai Khan. On returning to Venice, he was imprisoned and dictated his account of his journey to Rusticello, one of his fellow prisoners. The palace of the Great Khan, which Marco Polo describes here, prefigured the Forbidden City. It occupied roughly the same site, was arranged in the same way along a north–south axis and was also enclosed within a continuous surrounding wall.

The Great Khan usually resides during three months of the year, namely December, January and February, in the great city of Kanbalu [Beijing], situated towards the north-eastern extremity of the province of Cathay. Here, on the southern side of the new city, is the site of his vast palace, the form and dimensions of which are as follows....

Within these walls, which constitute the boundary of four miles [over six kilometres], stands the palace of the Great Khan, the most extensive that has ever yet been known. It reaches from the northern to the southern wall, leaving only a vacant court, where persons of rank and the military guards pass and repass. It has no upper floor but the roof is very lofty. The paved foundations or platform on which it stands is raised ten spans above the level of the ground, and a wall of marble, two paces wide, is built on all sides. This wall serves as a terrace, where those who walk on it are visible from without. Along the exterior edge of the wall is a handsome balustrade, with pillars, which the people are allowed to approach. The sides of the great halls and the apartments are ornamented with dragons in carved work and gilt, figures

of warriors, of birds, and of beasts, with representations of battles. The inside of the roof is contrived in such a manner that nothing besides gilding and painting presents itself to the eye. On each of the four sides of the palace there is a grand flight of marble steps, by which you ascend from the level of the ground to the wall of marble which surrounds the building, and which constitute the approach to the palace itself.

The grand hall is extremely long and wide, and admits of dinners being there served to great multitudes of people. The palace contains a number of separate chambers, all highly beautiful, and so admirably disposed that it seems impossible to suggest any improvement to the system of their arrangement. The exterior of the roof is adorned with a variety of colours, red, green, azure, and violet, and the sort of covering is so strong as to last for many years. The glazing of the windows is so well wrought and so delicate as to have the transparency of crystal.

In the rear of the body of the palace there are large buildings containing several apartments, where is deposited the private property of the monarch, or his treasure in gold and silver bullion, precious stones, and pearls, and also his vessels of gold and silver plate. Here are likewise the apartments of his wives and concubines, and in this retired situation he dispatches business with convenience, being free from every kind of interruption.

Marco Polo, *The Travels of Marco Polo*, ed. Manuel Komroff, 1928

A Jesuit in Beijing

Louis Lecomte (1655–1728) was part of the French embassy dispatched by Louis XIV to Siam in 1685. With five of his companions, he set sail for China in 1686 and reached Beijing two years later. He was granted a special audience by Emperor Kangxi (overleaf). Upon returning to France, Lecomte published the account of his journey in the form of letters addressed to the great figures of the realm.

Until then, we had not had the honour of seeing the emperor; the formalities of the *Lipou* (Tribunal of Rites) had to precede our audience; but as soon as the first president of this tribunal had placed us in the hands of our fathers, two eunuchs came to the College to tell the superior to come the next day with all his companions to a courtyard in the palace which he noted down. We were informed of the ceremony that must be observed on these occasions; but we had already become Chinese and there was no difficulty in instructing us.

We had to go in a chair as far as the first gate, from where we crossed on foot eight courtyards of astonishing length, surrounded by buildings of different architecture, but of very mediocre beauty, with the exception of the large square pavilions, built on the communicating gates, which had something grand and monumental about them. These gates, which lead from one courtyard to the other, were of remarkable thickness, wide, tall, well-proportioned and built of white marble, whose shine and beauty had been faded by time. A stream of running water cut across one of these courtyards and could be crossed by several small bridges made of marble that was similar, but whiter and more beautifully carved.

It is difficult, Madame, to go into great detail and to provide a description of this palace that would please you because its beauty lies not so much in the separate pieces of architecture of

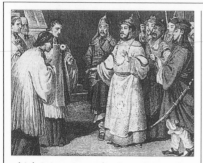

which it is composed as in an impressive array of buildings and an infinite series of courtyards and gardens neatly laid out, where everything is truly magnificent and shows the power of the master who lives there.

The only thing that struck me, and which seemed to me to be remarkable of its kind, was the emperor's throne. This is the image I have retained of it: in the middle of one of these vast courtyards, one sees a base, or a solid mass of extraordinary magnificence, square and isolated on all sides, with a balustrade, worked in a manner similar to our own taste, running all around its pedestal. This initial base is surmounted by another smaller one, embellished with a second balustrade similar to the first. The construction rises in this manner to five tiers, each one smaller than the others. At the top a large square hall has been built in stone with a roof, covered in golden tiles, resting both on the four walls and a regular succession of large painted columns, which support the structure and contain within the throne of the emperor.

These vast bases, these five white marble balustrades which rise one above the other and which, when the sun shines, seem to be crowned by a palace glittering with gold and varnish, have something magnificent about them,

particularly as they are situated in the middle of a great courtyard and surrounded by four groups of buildings. Were one to add to this plan the ornament of our own architecture and the beautiful simplicity that gives relief to our own works, this would perhaps be the most beautiful throne that art ever erected to the glory of the greatest princes.

Louis Lecomte
Un jésuite à Pékin. Nouveaux mémoires sur l'état présent de la Chine, 1687–92
1990

'How the Emperor of China leaves the palace on ordinary days and on ceremonial occasions'

In the 17th century the Portuguese missionary Gabriel de Magaillans lived at the court in Beijing from 1648 to his death in 1677. He has left a detailed description of the occasions on which the emperor left the Forbidden City.

The emperor leaves his palace on two occasions. The first, when he goes hunting or for a ride, which is considered a private activity, and so he is only accompanied by his guards, the princes of royal blood and other great lords, who go in front, behind, or to the side, according to their rank and their pre-eminence. This entourage consists of about two thousand men all on horseback and with magnificent attire, weapons and harnesses on their horses, and one sees nothing but silk fabrics, gold and silver embroidery and precious stones...

The second occasion is when the emperor goes out to make some sacrifice, or for some other public ceremony, and then he proceeds in this fashion.

First of all, twenty-four men appear

with large drums, in two rows of twelve, like all those who follow.

Second, twenty-four trumpets, twelve in a row.... These trumpets are more than three feet [almost one metre] long, and almost a palm in diameter at the mouthpiece. They are bell-shaped, decorated with bands of gold, and are in harmony with the sound and tempo of the drums.

Third, twenty-four batons, twelve in a row, seven to eight feet [about two metres] long, painted in red and decorated with gilded foliage, as are their ends.

Fourth, one hundred halberds, fifty in a row, with their crescent-shaped blades.

Fifth, one hundred gilded wooden maces, fifty in a row, with batons the length of a lance.

Sixth, two royal poles known as *Cassi*, painted in red with flowers, and gilded ends.

Seventh, four hundred large lanterns, richly decorated, and curiously carved.

Eighth, four hundred torches, highly ornamental and made of a wood that keeps a fire going for a long time and makes it extremely bright.

Ninth, two hundred lances, decorated at the base of the blade, some with silk flanges in various colours, others with the tails of panthers, wolves, foxes and other animals.

Tenth, twenty-four banners on which are painted the signs of the Zodiac, which the Chinese divide into twenty-four parts, while we only divide it into twelve.

Eleventh, fifty-six banners, depicting the fifty-six constellations, into which the Chinese group all the stars.

Twelfth, two hundred large fans supported by long batons, gilded and painted with various images of the sun, dragons, birds and other animals.

Thirteenth, twenty-four richly decorated parasols, and also in two rows, as has been mentioned.

Fourteenth, eight kinds of utensils, which the king normally uses, like a tablecloth, a gold basin, a ewer in the same material, and other similar items.

Fifteenth, ten snow-white horses, with saddles and bridles decorated in gold, pearls and precious stones.

Sixteenth, one hundred lancers emerge, from the two sides within the pages of the emperor's chamber, and in the middle the emperor himself, with a grave and majestic air, on a very handsome horse, and covered by a parasol of incredible beauty and magnificence, and so large that it shades both the king and the horse.

Seventeenth, the princes of royal blood, the little kings, and a large number of great lords, superbly dressed and lined up on both sides, in ranks and rows according to their pre-eminence.

Eighteenth, five hundred of the emperor's young gentlemen, richly dressed.

Nineteenth, one thousand men, in rows of five hundred, known as *Hiao gûei*, that is footmen, dressed in red robes that are embroidered with flowers and gold and silver stars and in caps decorated with long straight feathers.

Twentieth, an open chair borne by thirty-six men, followed by a second covered one, as large as a room, and borne by one hundred and twenty men.

Twenty-first, two huge chariots, each drawn by two elephants.

Twenty-second, a large chariot drawn by eight horses, and a smaller one drawn by four. All these chariots or carriages, the elephants and their riders, the horses and their coachmen, are richly adorned, and each chair and each chariot is followed by a captain with fifty soldiers.

Twenty-third, two thousand scholarly mandarins, a thousand in a body.

Twenty-fourth, two thousand mandarins-at-arms, all magnificently dressed in their ceremonial attire. They bring up the rear of the emperor's splendid procession, when he goes out in public.

Gabriel de Magaillans
Nouvelle Relation de la Chine contenant la description des particularités les plus considérables de ce grand Empire
1688

A banquet at the imperial court (letter dated 8 October 1727)

The Jesuit priest Antoine Gaubil (1689–1759) lived in China between 1723 and 1759. He was one of the greatest Sinologists of the 18th century and maintained a learned correspondence with some of the finest minds of his time, including the German philosopher Leibniz.

On 26 January of this year 1727, the emperor summoned the Europeans to the palace. This was in order to render them an unprecedented honour. We were informed that the emperor wished to eat with us in his great hall. Twenty people were chosen and I was one of them. A eunuch in the emperor's service led us at quarter past four in the afternoon into the prince's presence. We found him sitting on an extremely high and magnificent platform. Ten Europeans went to the left, and ten to the right and then we knelt and greeted His Majesty in the Chinese manner.

The emperor started by saying that he had not yet entertained us, that he wished to do so this year, and that he had resolved to be one of the party. We thanked him for such a great honour with a nod of the head and ten tables

for two were prepared, and one for the emperor. The meal was splendid, the emperor encouraged and invited us several times to drink, and once at the same time as he did, which is an extraordinary honour here. This prince highly praised Father Castillon, a Jesuit, and Italian painter; he wanted Father Parennin to speak of the past wars between Sweden and Muscovy; he enquired about the differences between ourselves and the Muscovites in religion, and told us that we were accused of having no respect for the dead ancestors.

Father Parennin explained very clearly the Christian doctrine concerning respect for father and mother, etc.

The emperor assured us that like us he believed in and honoured an author and creator of all things, and that we were very mistaken if we believed that he regarded the man known as *Fo*, who came in the past from India to China, as God.

His Majesty also wanted to be informed about the conjunctions of the planets and asked many questions regarding their calculation. He told us that M. Metello de Menesés, the Portuguese ambassador, had left Canton [Guangzhou] to come to court. Then each of us were given two bags, two sables, and in front of us he ordered three tables covered with fruit to be taken to the three Jesuit churches. After having bowed our heads, we left. Outside we were given, again on behalf of His Majesty, oranges and other fruit of all kinds.

There are those magnificent meals where a European dies of hunger here. The way in which he is forced to sit on the ground on a mat with crossed legs is awkward; neither the wine nor the dishes that are offered are to his taste. He has to be careful he does not need to

spit, to cough or to blow his nose. Every time the emperor says a word which lets it be known that he wishes to please, one must kneel down and hit one's head on the ground. This has to be done every time someone serves him something to drink. Besides, a European is fortunate to see the ceremonies that are observed when His Majesty is served. Everything is done with an order and majesty that inspire respect. In these kinds of ceremonies, it is clearly seen that a great master is being served. There is nothing cleaner or more magnificent than the dishes and bowls, and one would initially say that it was an idol to whom a sacrifice was going to be made rather than a prince to whom food is being served.

Ninette Boothroyd and Muriel Détrie
Le Voyage en Chine
Anthologie des voyageurs occidentaux du
Moyen Âge à la chute de l'Empire chinois
1992

An English ambassador in Beijing

Aeneas Anderson was first officer on board The Lion, *the ship that carried the British diplomatic mission sent by George III to Emperor Qianlong in 1793. The failure of this embassy, headed by Lord Macartney, inspired him to write the famous saying: 'We entered Pekin [Beijing] like paupers; we remained in it like prisoners; and we quitted it like vagrants.'*

As I had this day attended the Ambassador, I shall just mention what I saw of the imperial palace, which will be comprised in a very few lines.

It is situated in the centre of the city, and surrounded by a wall about twenty feet [six metres] in height, which is covered with plaster painted of a red colour, and the whole crowned or capped with green varnished tiles. It is

said to occupy a space that may be about seven English miles in circumference and is surrounded by a kind of gravel walk: it includes a vast range of gardens, full, as I was informed, of those artificial beauties which decorate the gardens of China. I can only say that the entrance to the palace is by a very strong stone gateway, which supports a building of two stories; the interior court is spacious, and the range of building that fronts the gateway rises to the height of three stories, and each of them is ornamented with a balcony or projecting gallery, whose railing, palisados, and pillars are enriched with gilding; the roof is covered with yellow shining tiles, and the body of the edifice is plastered and painted with various colours. This outer court is the only part of the palace which I had an opportunity of seeing, and is a fine example of Chinese architecture. The gate is guarded by a large body of soldiers, and a certain number of mandarins of the first class are always in attendance about him.

Of the magnificent and splendid apartments this palace contains for private use or public service; of its gardens appropriated to pleasure, or for the sole production of fruit and flowers, of which report said so much, I am not authorized to say anything as my view of the whole was very confined; but though I am ready to acknowledge that the palace had something imposing in its appearance when compared with the diminutive buildings of the city that surround it, I could see nothing that disposed me to believe the extraordinary accounts which I had heard and read of the wonders of the imperial residence of Pekin.

Aeneas Anderson
A Narrative of the British Embassy
in China, 1796

Emperors of China

Through a sense of honour or out of dynastic piety, some emperors chose to cut short their reign. Chongzhen and Qianlong were two examples.

V iew of the Forbidden City with Coal Hill in the distance.

The fate of the last Ming emperor

Emperor Chongzhen (1628–44) was the last emperor of the Ming dynasty (1368–1644). Driven to suicide by his military defeats, he took his faithful servant and eunuch with him to his death. From the summit of Coal Hill, he contemplated the Forbidden City for the last time.

It was nearly five AM and the dawn was breaking. The emperor changed his apparel and removed his long imperial robe. The bell rang in the palace for the morning audience, but none attended. The emperor donned a short, dragon-embroidered tunic and a robe of purple and yellow, and his left foot was bare. Accompanied by the faithful eunuch Wang Ch'eng-en, he left the palace by the Gate of Divine Military Prowess [the Gate of Divine Military Genius] and entered the Coal Hill enclosure. Gazing sorrowfully upon the city, he wrote, on the lapel of his robe, a valedictory decree: 'I, feeble and of small virtue, have offended against Heaven;

Emperor Qianlong.

the rebels have seized my capital, because my ministers deceived me. Ashamed to face my ancestors, I die. Removing my imperial cap and with my hair dishevelled about my face, I leave to the rebels the dismemberment of my body. Let them not harm my people!' Then he strangled himself in the pavilion known as the 'Imperial Hat and Girdle Department', and the faithful eunuch did likewise.

E. Backhouse and J. O. P. Bland
Annals and Memoirs of the Court of Peking (from the 16th to the 20th century)
1914

Emperor Qianlong renounces the throne

Emperor Qianlong succeeded to the throne in 1736. After ruling for almost sixty years, he decided to give up power because he did not wish to reign for longer than his grandfather, Emperor Kangxi.

I have now reigned for fifty-nine years. By the favour of high Heaven and the protection of my ancestors, peace prevails throughout my dominions, and new territories have come to share the blessings of China's civilization. During all these years, I have striven to alleviate my people's lot and to show myself worthy of Heaven's blessings. Again and again have I granted exemptions of land tax in times of flood and famine and bestowed upon the sufferers over ten million taels from my privy purse.

Next year will witness the sixtieth anniversary of my succession to this goodly heritage of the Throne: few, indeed, of my predecessors in this and other dynasties, have completed a sixty-year cycle. Those among them who have reigned over sixty years came to the Throne in early childhood, whereas I was twenty-five years of age at my accession. Today I am eighty-four, and my natural strength is not abated. I rejoice in the possession of perfect health, and my descendants to the fourth generation surround me. Immeasurably thankful as I am to the Almighty for His protection, I feel encouraged to yet further endeavour. On New Year's Day of my sixtieth year an eclipse of the sun is due, and on the Festival of Lanterns (1st Moon, 15th day) there will be a lunar eclipse. Heaven sends these portents as warnings, but a Sovereign's duty is to be guided by his conscience and to be aware of his shortcomings at all times, so that an eclipse is not needed to awaken him to a sense of duty. To find favour in the sight of Heaven he must regulate his conduct. There is no need for empty catchwords and platitudes on the occasion of such natural events.

E. Backhouse and J. O. P. Bland
Ibid.

In the service of the Sons of Heaven: eunuchs and concubines

Within the Forbidden City resided the emperor, the imperial wives and concubines, attended by the ladies-in-waiting, eunuchs and servants. This population is estimated to have numbered several thousand people.

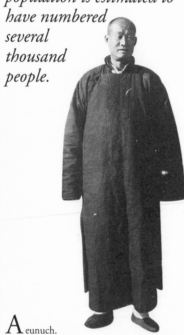

A eunuch.

My early days in the Forbidden City

Yu Chunhe was a eunuch in the service of Empress Xiaoding, wife of Emperor Guangxu (1875–1908). He lived in the Forbidden City for eighteen years and witnessed the end of the empire. His memoirs were compiled by the historian Dan Shi.

I had barely turned seventeen on that autumn day in 1898, when I made my entrance into the Forbidden City. I rediscovered the same fifteen companions at the doors of the office of the Imperial Household Department where we were met by an old eunuch. He gathered us in the hall of a neighbouring pavilion and explained that we were about to embark upon a two-week period of apprenticeship. He was going to be our instructor, to teach us the rules and customs of the court, and the rudiments of our work.

His first lesson concentrated on the way in which it was necessary to address the various members of the palace. He taught us that the emperor could only be referred to as Eternal Lord or Illustrious Lord, that the Empress Dowager Cixi, his aunt, was the Venerable Grandmother or the Old Buddha and that the concubines were distinguished by their name preceded by *Mistress*. Likewise, amongst eunuchs, certain codes had to be respected. The word eunuch was to be banished from the vocabulary adopted to indicate one of one's fellow men; one said *Master* to those of a rank superior to one's own, and *Colleague* to those of equal rank.

The following days were devoted to greetings and prostrations. I had never until then imagined that one could kneel down in so many ways and on such a variety of occasions. To listen to

him, a eunuch spent his life on his knees. One had to kneel, for example, every time a concubine addressed us, placing the left knee before the right; this order, he insisted, was of the utmost importance. Once down on one's knees, back straight as a broom-handle, one humbly removed one's hat and placed it on the ground, to the right of one's body. Before a chief eunuch or an official of lesser importance, one used only one knee, but to render homage to the emperor or his wives, it was necessary to kneel three times and to strike the ground with one's forehead nine times; and there was no question of doing this lightly, for as the sound of the blow was proportionate to the gratitude expressed, it was vital that the sound should be heard by everyone. For hours, I skinned my forehead in front of imaginary concubines, under the exacting eye of our teacher, who cared little about our bumps, while praying to Heaven to protect me from having to show gratitude too often.

We then familiarized ourselves with the rules of service, for we were not there for the proprieties; we were going to have to pour tea or alcohol, to fill pipes, to light cigarettes, to serve meals, to dress the person into whose personal service we were assigned. I imagined, upon setting foot in the Forbidden City, that I was going to serve the emperor; in fact, the latest arrivals served the servants and never came near those in high places in the palace. The eunuchs were organized into a definite hierarchy and, as they rose in rank, had their own servants at their disposal. Hence Li Lianying, the head of the palace of the empress dowager, enjoyed the right to have several dozen eunuchs exclusively at his disposal. I thus learnt to serve those who, in their turn, served those more

powerful; the task was no easier because of this, for within the Forbidden City, each gesture one made was governed by strict and unchanging rules, and to pass a simple object an entire ceremonial had to be observed. Thus, when a master wanted some tea, it was necessary to raise the cup gently with both hands, and to approach him holding it respectfully on joined palms held at chest height before coming to kneel at his feet. Once on one's knees, one had to hold the beverage out to him, neither too high, nor too low; at eyebrow level, our instructor told us, and with the head bowed as a sign of humility.

Dan Shi
In *Mémoires d'un eunuque
dans la Cité interdite*
1991

Entering the Palace of Concentrated Beauty

He Rong Er was a lady-in-waiting during the period of the last emperors. She entered the service of the Empress Dowager Cixi when she was thirteen. Her duty was 'to serve her when she smoked'. After an unhappy marriage to the eunuch Liu, she left the imperial palace for ever and earned her living as a domestic help. Here she recounts being presented to the 'aunts'.

Court tradition dictated that the eunuchs were always men of Han race, that is to say true Chinese, while the ladies-in-waiting whatever their rank all had to be Manchus. For example, a Chinese Han woman could never become a lady-in-waiting to the empresses, the wife of the emperor, or a concubine or *gege*, a princess. The ladies-in-waiting in the Palace of Concentrated Beauty had to be of pure Manchu origin.

But the rules that the ladies-in-waiting in the Palace of Concentrated Beauty had to follow were much stricter than those required in other palaces. After kneeling before the empress dowager, we were taken before the *gugu*, the aunts. I had been told that it was sometimes more difficult to serve the aunts than the empress.

In accordance with the palace rules, from the age of eighteen or nineteen, that is after four or five years of service, a lady-in-waiting could leave service and find a husband. Those ladies-in-waiting who had not yet left the palace were, to the new recruits, the 'aunts'. Each of us had an aunt. They were highly respected and exerted great power over us. They could beat us, punish us, treat us as idiots while allocating us heavy and lowly tasks to do. But usually they were anxious to abandon their role and to find fresh young girls to replace them. For this reason, they willingly passed on their knowledge to us, so that they could rapidly inform the grade superior to them that we were already experienced enough to replace them. My aunt was very quick-tempered. She often beat me for a mere trifle. But the blows were still easier to bear than various other punishments. For example, when she ordered me to kneel in a corner, I never knew when I would be able to get up again. It often reached the point where I would beg her: 'Good aunt, rather than punishing me like this, beat me.' The girls who had started at the same time as I were in the same situation.

We also had to attend to their toilette. We washed their feet and even their bodies. Every day we carried at least a dozen buckets of hot water. We did sewing for them. The aunts loved to get dressed up, and sometimes were encouraged by the empress dowager herself. They competed amongst themselves for the robes, stockings and shoes. We also had to do their laundry. Our days were extremely busy. We got up very early and went to bed very late. Life was not easy.

Jin Yi
In *Mémoires d'une dame de la cour dans la Cité interdite*
1993

The emperor and his concubine

Through skill or intrigue, some concubines managed to rise to the enviable status of favourite.

The emperor enjoyed only the company of the concubine Zhen Fei. According to court rules, for security, a concubine called by the emperor had to be brought to him naked, wrapped in a great black cloak. A eunuch carried her on his back into the emperor's bedchamber. This was known as *bei gong*: 'entering the emperor's bedchamber on the back'. In the evening the eunuch presented the emperor with a list of the women available. Then, armed with a lantern, he went to collect the chosen one. Guided by the eunuch, two female followers escorted the concubine into the side room of the emperor's palace. She washed, undressed, then announced in a frail voice: 'The emperor's

wish shall be granted.' The eunuch lifted her on to his back and carried her into the chamber.

Most of the women summoned by the emperor were treated in this way, except for the concubine Zhen Fei. Instead of *bei gong*, she did *zou gong*: 'walking into the palace'. She was the emperor's closest companion. He sometimes summoned the concubines he liked best to where he was working, something an ordinary lady could never do! The concubine came in, disguised as a man with a Manchu cape, the long plait well hidden at the back, a pearl-covered cap on the head and thick-soled shoes, which gave her the appearance of a young scholar. Dressed like this, she could hold the emperor's inkwell and talk with him. But she did not have the right to discuss politics; she could only talk about poetry or play chess with him. This was the most enviable position for a woman in the palace. Only the concubine Zhen Fei had this privilege. Even the mistress Long Yu was jealous of her. And Cui Yu Gui, Liu's friend, told us that it was perhaps for this reason that the empress had her thrown into a well, claiming that she had discussed politics with the emperor and monopolized him too much.

Jin Yi
In *Mémoires d'une dame de la cour dans la Cité interdite*, 1993

Palace politics

The reign of the last emperor, Puyi (1906–67), ended with his abdication in 1912, though he was permitted to remain in the palace until his expulsion in 1924. This account from his autobiography provides a vivid insight into the corruption and intrigue that formed part of daily life at the imperial court.

The eunuchs had many ways of augmenting their incomes. There are descriptions in plays and novels of how Emperor Kuang Hsu [Guangxu] had to give money to Li Lien-ying [Li Lianyang], the chief eunuch of the palace of the Empress Dowager Tzu Hsi [Cixi], as otherwise he would make things difficult for him and refuse to announce him when he went to pay his respects to Tzu Hsi. While such things as these could not have happened I did hear a great deal about how the eunuchs used to extort money from high officials. At the time of Emperor Tung Chih's [Tongzhi's] marriage the Household Department missed out one part of the palace in the distribution of bribes. On the wedding day the eunuchs of this section sent for an official of the Household Department saying that a pane of glass in one of the windows of the palace in question was cracked. As a Household Department official he was not allowed to mount the terrace of the palace unless he had been specially summoned, so he could only see the crack from a distance. He was terrified, he would be in very deep water if Tzu Hsi heard that there was something as ill-omened as a broken window on the wedding day. The eunuchs then said that there was no need to go and look for a workman as they could discreetly change the pane themselves. Although he realized that this was a racket the Household Department man had no option but to send over a sum of money; as soon as this was done the window was repaired. This was not very difficult as the 'crack' in the glass was only a strand of hair stuck on to it.

Puyi
From Emperor to Citizen,
trans. W. J. F. Jenner
1987

Extraordinary travels

To satisfy the appetite of a public eager for exoticism and a change of scene, Jules Verne and Paul d'Ivoi dispatched their characters on travels through distant lands. The Reverend McGhee went to the Forbidden City in person and presents a more sober account of his travels.

LES VOYAGES EXTRAORDINAIRES

LES

TRIBULATIONS

D'UN

CHINOIS EN CHINE

PAR

JULES VERNE

DESSINS PAR BENETT

BIBLIOTHÈQUE
D'ÉDUCATION ET DE RÉCRÉATION
J HETZEL ET Cⁱᵉ, 18, RUE JACOB
PARIS
Tous droits de traduction et de reproduction réservés.

Is Jules Verne serious?

In The Tribulations of a Chinaman *(illustrations this page and opposite), Jules Verne (1828–1905) compiled an accurate list of the buildings and palaces that constitute the Forbidden City. The abundant use of epithet as well as figures, however, leave readers with the impression that the celebrated novelist has sought to entertain rather than educate them!*

The Forbidden City is surrounded by red brick walls crowned with yellow tiles. It is entered by the Gate of Great Purity, which is only opened for an emperor or empress. Within are the temple of the ancestors of the Tartar dynasty, with a double roof of variegated tiles; Che and Tsi, the temples consecrated to spirits celestial and terrestrial; the Palace of Sovereign Concord, reserved for state ceremonies and official banquets; the Palace of Intermediate Concord, where may be seen the genealogical tables of the 'Son of Heaven'; and the Palace of Protecting Concord, of which the central hall is occupied by the imperial throne. Then there is the pavilion of Nei-ko, where the great council of the empire is held, under the presidency of Prince Kong, the minister of foreign affairs, and uncle to the late sovereign; the pavilion of the Flowers of Literature, whither the emperor repairs once a year to interpret the sacred books; the pavilion of Tchooan-Sin-Tien, where sacrifices are offered in honour of Confucius; the imperial library; the offices of historians; the Voo-Igne-Tien, where the wooden and copper plates used for printing are carefully preserved; and the workshops where the court garments are concocted. Then might be seen the Palace of Celestial Purity, used for the discussion

of family affairs; the Palace of the Terrestrial Element, where the young empress was installed; the Palace of Meditation, to which the sovereign retires when he is ill; the three palaces where the emperor's children are brought up; the four palaces reserved for the widow and court-ladies of Hien-Fong, who died in 1861; the Tchoo-Sicou-Kong, the residence of the emperor's wives; the Palace of Proffered Favours, where the court-ladies hold their official receptions; the Palace of General Tranquillity, a strange name to be applied to a school for the children of the superior officers; the Palace of Purification and Fasting; and the Palace of the Purity of Jade, occupied by the princes of the blood-royal. There were the temples dedicated to departed ancestors, to the presiding deity of the town, and another of Tibetan architecture; there were the imperial

stores and offices; the Lao-Kong-Choo, the residence of the eunuchs, of which there are no less than 5000 in the Red Town; and many other palaces besides, making a total of forty-eight within the imperial enclosure, not including the Tzen-Kooang-Ko, the Pavilion of Purple Light, on the borders of the lake of the Yellow Town, where on 19 June 1873, the Ambassadors of England, Russia, Prussia, Holland, and the United States were admitted into the presence of the emperor. The Wan-Cheoo-Chan, too, should not be omitted from the summary. This is the Summer Palace, and is situated about five miles from Peking. It was destroyed in 1860, and among its ruins the garden of Calm and Perfect Light, the mound of the Source of Jade, and the hill of Ten Thousand Lives, can hardly be discerned.

Never did an ancient town exhibit an agglomerate of buildings with forms so varied, and contents so rare; never has any European capital been able to boast a nomenclature so strangely fantastic.

Jules Verne
The Tribulations of a Chinaman
trans. Ellen E. Frewer, 1883

The burning of the Summer Palace

The Reverend McGhee served with the expeditionary force sent to China in 1860. Lord Elgin at one point considered destroying the Forbidden City but decided instead to burn down the Summer Palace of Yuanmingyuan, which was already being looted by the French and British. When the closed gates came down, the Forbidden City was revealed.

I turned the corner of a high wall round which the paved road led, and before me was a dense mass of smoke, and the fierce blaze of the raging fire towering above it, and far above the trees. A

temple, which means not one building but a whole cluster of separate edifices, circling round one great shrine, was in flames, and communicating destruction to the noble trees, in and around it, which had shed their grateful shade over it for many a generation: its gilded beams and porcelain roof of many colours, in which of course the imperial yellow claimed the superiority – all, all, a prey to the devouring element. You could not but feel that although devoid of sympathy for its deity, there was a sacrilege in devoting to destruction structures which had been reared many, many hundred years ago; nor was it the buildings only, adorning as they did the scenery, which claimed your sympathy, but every building was a repository of ancient and curious art, enamels made before the present dynasty of China, books to no end, engravings of all sorts of scenes, historical, illustrating the wars of the Chinese and Tartars, some the production of a purely native talent, and others by Jesuit missionaries, and drawn in the Chinese style. These missionaries are generally learned in something else besides religion, and thus they beat ours out of the field altogether. Embroidered hangings of enormous value, altar furniture plated with gold, things, which, apart altogether from their value, were full of interest from their beauty and rarity, all devoted to destruction; some few were saved by officers, but as carriage was difficult, but few....

The troops are halted here for about an hour, and the various corps receive their orders from Sir J. Michel as to where they are to carry on the work of destruction. Looking up from the entrance of the park, the groups of buildings which were scattered through the thickly wooded hollow in the hillside extended for about a mile and a half

up the hill, and reached about half-a-mile right and left of the entrance; soon after the order was given, you saw a wreath of smoke curling up through the trees that shaded a vast temple of great antiquity, which was near the centre of the park, and roofed with yellow tiles that glistened in the sun, moulded as they were in every grotesque form that only a Chinese imagination could conceive; in a few minutes other wreaths of smoke arose from half-a-hundred different places, each like the smoke from some gamekeeper's cottage, hidden in the woods on a hill side in some park at home.

Soon the wreath becomes a volume, a great black mass, out burst a hundred flames, the smoke obscures the sun, and temple, palace, buildings and all, hallowed by age, if age can hallow, and by beauty, if it can make sacred, are swept to destruction, with all their contents, monuments of imperial taste and luxury. A pang of sorrow seizes upon you, you cannot help it, no eye will ever again gaze upon those buildings which have been doubtless the admiration of ages, records of by-gone skill and taste, of which the world contains not the like. You have seen them once and for ever, they are dead and gone, man cannot reproduce them.

Rev. R. J. L. McGhee
How We Got to Pekin: A Narrative of the Campaign in China of 1860
1862

Paul d'Ivoi

Paul d'Ivoi recounts the adventures of a 'true Parisian' dispatched on a secret mission to Beijing. Arrested for the crime of lese-majesty against the Empress Tsou-Hsi [Cixi], Cigale is thrown into prison. There he discovers his friend the diplomat René Loret. The two

prisoners cross the Forbidden City in a sedan chair.

The escort turned south again and then swept under the West Flowery Gate [Xihuamen]…[of] the Forbidden City, which only the imperial family, slaves and officials were permitted to enter.

Cigale opened his eyes wide, thrilled to the very depths of his soul to be admitted to wander around the jumble of palaces – the Palatine – which together constitute the Red City, so jealously barred, not only to Europeans but also to the Chinese people….

Loret indicated to his companion the buildings standing before them and murmured:

'Look, there is the palace of the empress dowager.'

It would be impossible to describe the extravagance of this palace. Considering its purpose, the artists responsible for its decoration had gathered together all the strange, complicated, crazy ideas so dear to the Chinese mind.

An abundance of roofs with rounded points, of pinnacles, of bell-towers, of winding and historiated ridge tiles; the carved motifs became tangled on the walls, a polychrome collection of lacquered wood, marble, stucco; one detail will suffice to provide an idea of the palace's strangeness. The steps leading to the apartment on the ground floor are flanked by gilded ramps, representing dragons who threaten visitors with their open jaws and whose scaly tails stand upright like columns to support the sloping roof, stretched like vellum above the terrace-veranda.

A few minutes later, released from their moving prison, the captives were carefully shut in a pavilion situated to the east of the main group of buildings reserved for Tsou-Hsi and her retinue.

Immediately opening the windows, fitted with yellow awnings bearing the image of a writhing green dragon, they examined their surroundings. Their windows overlooked a small flower-filled courtyard set behind the palace.

Beyond, lined up in a triumphal avenue, was a succession of gleaming red and gold lacquer gates: Gate of the Residence of the Empress, Gate of the Divine Warrior, Upper North Gate. Several hundred metres away, the artificial summit of the Beautiful or Coal Hill (Kin-Chan) blocked the view with its conical slope, stretched before the horizon like a screen.

The dwellings of the slaves and eunuchs lined the sides of the courtyard.

After a quick inspection, Cigale grumbled: 'We've made nothing on the deal. Our prison is easier to guard than the other one.'

And, with a weary nod, Loret agreed.

'Well', concluded the Parisian, with the audacity and calmness of his compatriots, 'it'll also be much more fun to slip through the mandarins' fingers.'

His companion looked at him, astonished.

'Can you see a way to escape?'

'No, not yet. If I do, we'll get out. Don't you worry, I'll find one….'

The diplomat looked doubtful. Escape clearly appeared unlikely to him.

And events seemed to prove him right.

Paul d'Ivoi
Cigale en Chine
1927

Fiction and fables

In contrast to Jules Verne and Paul d'Ivoi, Segalen and Kafka lead us on an inner journey. Their Forbidden City has all the semblance of an inaccessible mystery.

'Violet Forbidden City' (1912)

Victor Segalen (1878–1922) was an avid traveller and one of the founders of the French school of Chinese archaeology. He learnt classical Chinese and married a Chinese woman. Instead of describing the Forbidden City itself, he transforms it into an allegory of his inner self in this poem. The end of the poem alludes to the death of Emperor Guangxu's favourite concubine, drowned on the orders of the Empress Dowager Cixi.

It is built in the image of Pei-king,
 capital of the North, with a climate
 either excessively steamy, or else
 colder than excessive cold.

Around it, the merchants' houses, inns
 open to all and sundry with their
 transient beds, their fodder racks and
 dung heaps.

Towards the rear, the lofty ring wall, the
 Conqueror, with its jagged ramparts,
 redans, corner turrets for my worthy
 defenders.

B̲elow: Victor Segalen in his study in Beijing.

In the centre, this red wall, keeping for
 a small minority its square of perfect
 friendship.

But, central, underground yet superior,
 full of palaces, lotuses, stagnant
 waters, eunuchs and porcelains, – is
 my Violet Forbidden City.

*

I do not describe it; I do not surrender
 it; I have access by unknown routes.
 Unique, unique and solitary, bizarre
 male among this servile herd, I do not
 teach my retreat: my friends, if one of
 them thought of the Empire!

Now, I will open the gate and She will
 enter, the awaited, the all powerful
 and all innocent,

To reign, laugh and sing among my
 palaces, my lotuses, my stagnant
 waters, my eunuchs and my vases,

In order to be – that night when she
 shall understand – pushed gently
 down into a well.

> Victor Segalen
> *Steles*
> trans. Andrew Harvey and
> Iain Watson, 1990

René Leys (1922)

René Leys *is the story of a hopeless quest.
Throughout the novel, the narrator pursues
his hope of penetrating the Forbidden City.
He believes that he has achieved this aim
through the intervention of a young
European who has connections in the
imperial palace. But the story ends with
the death of René Leys, who takes its secrets
and mysteries with him to the grave.*

No one can deny that, in terms
of mystery, Pei-king is a superb
'production'. To begin with, the triple
plan of its cities obeys neither the
dictates of the cadastral assembly nor the
lodging requirements of such as feed and
breed. The capital of the greatest empire
under the sun was conceived for its own
sake, laid out like a chessboard in the
far north of the Yellow Plain, girt with
geometrical walls, ruled with avenues,
cross-ruled with alleys running at right-
angles, and raised in one monumental
sweep…and then, afterwards, occupied,
eventually to overflowing in the seedier
quarters, by its parasites, the Chinese
people. The principal square, however,
the Tatar/Manchu City, still harbours
the conquerors – and this dream….

Inside, deep in the innermost centre
of the Palace, a face: a child-man, and
emperor, Lord of the Sun and Son of
Heaven (whom everyone, including
journalists, insists on referring to as
'Kuang Hsu', which actually designates
the period of his reign, that is to say AD
1894–1908). His real name, his name
during his lifetime, was the
unutterable…. *Himself* – and it not
being permitted me to give the *name*,
I give the European *pronoun* all the
reverential emphasis of the Manchu
gesture (the two sleeves raised with
joined fists to meet the lowered
forehead) which designates him –
Himself remains the figure and incarnate
symbol of the most pathetic and most
mortal of creatures. Impossible deeds
are ascribed to him…and perhaps he
really and truly performed them. I am
convinced he died as none die nowadays
– of ten entirely natural ailments
but primarily of that eleventh
(unrecognized) ailment of being
emperor – that is to say the victim
appointed for the last four thousand
years as intercessory sacrifice between
Heaven and the People on earth….

And the place of his sacrifice, the
precinct within which his person was

immured, the Purple and Forbidden City – which now raises its ramparts against me – became the only possible stage for this drama, this story, this book which, without Himself, has no further justification…

<div style="text-align: right">

Victor Segalen
René Leys
trans. J. A. Underwood
1990

</div>

'An Imperial Message' (1919)

In Kafka's parable on the loneliness of power, the emperor of China's life is drawing to a close and he is trying to send a message to one of his humble subjects. Despite his efforts, the imperial messenger is incapable of finding a way out of the maze of corridors and courtyards in the imperial palace. The emperor's message will never reach its destination.

The emperor, so a parable runs, has sent a message to you, the humble subject, the insignificant shadow cowering in the remotest distance before the imperial sun; the emperor from his deathbed has sent a message to you alone. He has commanded the messenger to kneel down by the bed, and has whispered the message to him; so much store did he lay on it that he ordered the messenger to whisper it back into his ear again. Then by a nod of the head he has confirmed that it is right. Yes, before the assembled spectators of his death – all the obstructing walls have been broken down, and on the spacious and loftily mounting open staircases stand in a ring the great princes of the empire – before all these he has delivered his message. The messenger immediately sets out on his journey; a powerful, an indefatigable man; now pushing with his right arm, now with his left, he cleaves a

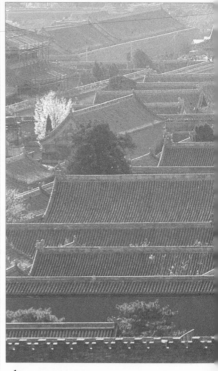

A maze of roofs.

way for himself through the throng; if he encounters resistance he points to his breast, where the symbol of the sun glitters; the way is made easier for him than it would be for any other man. But the multitudes are so vast; their numbers have no end. If he could reach the open fields how fast he would fly, and soon doubtless you would hear the welcome hammering of his fists on your door. But instead how vainly does he wear out his strength; still he is only making his way through the chambers of the innermost palace; never will he get to the end of

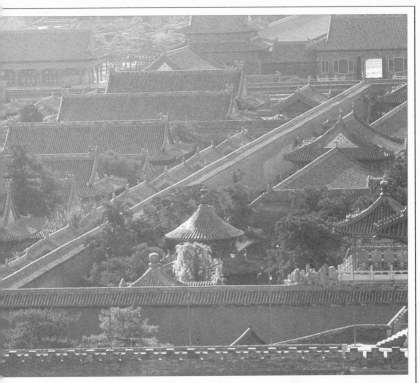

them; and if he succeeded in that nothing would be gained; he must next fight his way down the stair; and if he succeeded in that nothing would be gained; the courts would still have to be crossed; and after the courts the second outer palace; and once more stairs and courts; and once more another palace; and so on for thousands of years; and if at last he should burst through the outermost gate – but never, never can that happen – the imperial capital would lie before him, the centre of the world, crammed to bursting with its own sediment. Nobody could fight his way through here even with a message from a dead man. But you sit at your window when evening falls and dream it to yourself.

Franz Kafka
'An Imperial Message'
The Collected Short Stories of Franz Kafka
trans. Willa and Edwin Muir
1988

The twilight of a dynasty

The last Qing emperors lived in troubled times. China hesitated between turning in on itself and opening up to the West. The Forbidden City was soon to be no more than an empty stage, prey to looting and destruction.

Opposite: marines protecting the French Legation in Beijing in 1899.

Below: a deserted Forbidden City.

'A deathly silence'

In 1900 Pierre Loti (1850–1923) was part of the French expeditionary force sent to China to repress the Boxer Rebellion. He wrote several articles for Le Figaro *in which he described his admiration for 'the wonderful Peking which the war has just opened up to us'. This piece was written in 1902. While visiting the Forbidden City, he discovers an abandoned palace where 'a deathly silence' reigns.*

First of all, the great thick black wall, the Babylonian wall, the superhuman ramparts of a city more than ten leagues in circumference, now ruined and in decay, half abandoned and littered with bodies. Then a second great wall, painted deep blood red, which forms another great city, enclosed within the first. Then a third wall, more magnificent still, but the same blood red colour – a highly mysterious wall that had never, prior to these days of war and collapse, ever been crossed by a single European; today we had to wait there for over an hour, despite our signed and countersigned permits; through the locks of an inhospitable gate, surrounded by a squad of soldiers and barricaded from the rear by planks as in times of siege, it was necessary to threaten and to negotiate at length with

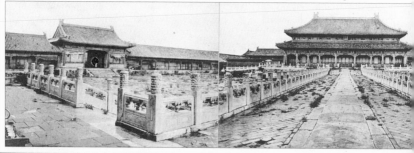

the guards inside who wished to slip away and escape. Once the heavy gates, reinforced with ironwork, were opened, yet another wall appeared, separated from the previous one by a patrol path, strewn with scraps of clothing and where some dogs were dragging the bones of corpses – a fresh wall once again of the same red, but even more magnificent, the whole of its infinite length crowned by horned decorations and golden yellow faïence monsters. And lastly, having crossed this final rampart, some beardless and curious old men, who came towards us greeting us suspiciously and led us through a maze of small courtyards, little walled and enclosed gardens, where ancient trees grew amongst the rockeries and Chinese porcelain vases, all of this separated, hidden, agonizing, all of this protected and haunted by a population of monsters, by bronze or marble chimeras, by a thousand figures emanating hatred and ferocity, by a thousand unknown symbols. And once again, in the red walls topped with yellow tiles, the gates behind us shut: it was like one of those terrible dreams in which a series of corridors opens up and then closes again, preventing you from ever getting out.

Now, after the long nightmare trip, one has the sense, instead of

contemplating the anxious group of people who led us, trotting silently in their paper stockings, the sense of some supreme and unprecedented profanation, which must have been committed in their eyes by penetrating this modest enclosed chamber: there, in the doorway, observing our slightest movement with sideways glances, are the crafty eunuchs in their silken robes, and the thin mandarins wearing sad raven's feathers in the red button of their hats. Forced nevertheless to surrender; they did not want to; resorting to various tricks, they tried to lead us elsewhere, in the immense labyrinth of Heliogabale's palace, to interest us in the darkly luxurious great halls that lie further on, in the great courtyards, over there, and in the great ramps of marble that we were to visit later, in a whole colossal and distant Versailles, overrun by the grass of graves and where only the singing of crows can be heard....

They were absolutely against it, and it was only through observing the play of their startled eyes that we guessed where we had to go.

So who lived there, isolated behind all these walls, all these walls a thousand times more appalling than those of our prisons in the West? Who was the man who slept in this bed, under these silks of midnight blue and, who, in his dreams, at nightfall, or even at dawn on

those icy winter days during the melancholy of his awakening, contemplated these pensive little bouquets in glass cases, symmetrically arranged on black chests?...

It was the invisible emperor, Son of Heaven, the sickly and infantile one, whose empire is more vast than the whole of our own Europe, and who reigns like a shadowy phantom over four or five hundred million subjects.

Just as the vigour of his almost deified ancestors, who remained stationary for too long in the depths of palaces more sacred than temples, is exhausted in his veins, so the place in which he chooses to live shrinks, degenerates and becomes enveloped in twilight. The immense surroundings of former emperors scares him, and he lets it all fall into decay; the grass grows, and wild bushes, on the magnificent marble ramps; in the impressive courtyards; crows and pigeons nest in their hundreds in the gilded vaults of the throne rooms, covering with dirt and droppings the sumptuously strange carpets left there to rot. This invincible palace, one league in circumference, which no one had ever seen, about which no one could know or could have imagined anything, reserved for the Europeans, who were about to enter it for the first time, the surprise of funereal decay and a deathly silence.

Pierre Loti,
'Les Dernier Jours de Pékin',
in *Voyages (1872–1913)*, 1991

Dr Dethève visits Emperor Guangxu

On 18 November 1898 Dr Dethève, the doctor to the French Legation in Beijing, was summoned to the imperial palace for a consultation. Accompanied by the Consul Vissière, who acted as interpreter, he had the distinguished honour of examining Emperor Guangxu.

The emperor, who was seated on a large chair covered with yellow satin cushions, with, before him, a very long and narrow table that was extremely simple, without any ornaments, wore the winter hat with red silk fringes and a knot in the same colour in place of the mandarin button or badge, and the plum or dark purple taffeta coat, without embroidered dragons. His aunt and adoptive mother was dressed in a blue silk gown, with borders embroidered with flowers on a white background; her headgear was that worn by Tartar women with a wide cross bar with mounted flowers of pearls or semi-precious stones at the front. She wore no rouge or colour on her face; she had a lively and haughty expression, the mark of great serenity. Her nose was very pronounced, even hooked, for someone of her race. On a previous occasion, Monsieur Vissière had seen her go past in a sedan chair almost entirely made of glass on her way to the Summer Palace: then her face had been completely painted and made-up, her clothes and headgear much more sumptuous and her look still more imperious.

In front of the empress dowager, also seated on an ample chair covered with cushions, was an even larger table, covered with a carpet of yellow satin reaching right to the floor on three sides.

After a silence, M. Vissière addressed the emperor, who was mild and sickly in appearance, with a thin and clean-shaven face, deep-set black eyes and looking barely more than half his twenty-eight years. He told him that the news of his illness had been learnt with deep regret, that Dr Dethève would be happy to attend to him and that he begged His Majesty to indicate the cause and nature of his discomfort. Another long silence followed, during which the

emperor observed his interlocutor as though he were embarrassed to reply; then, signalling with his eyes to Prince Qing, who immediately went to kneel beside him to hear him speak, he said in a very low voice: 'First of all, let my pulse be taken.' Dr Dethève then went to the corner of the room to the sovereign's right and felt his right pulse.

The audience lasted about fifty minutes; the patient agreed to let the doctor listen to his chest, keeping on only a single garment for the purpose, after having asked and obtained the permission of the empress dowager, and handed M. Vissière a note in his own hand, which he drew out from his boot and in which he had described in detail the origin of his illness and its various symptoms. During this encounter, the empress dowager intervened on several occasions, whether her adopted son had consulted her or not, the vibrant tone of her voice contrasting strangely with his.

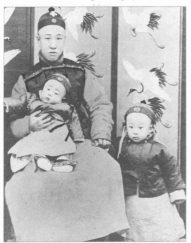

The infant Puyi, on the right, with his father before Puyi's enthronement.

Prince Qing or one of the other great chamberlains knelt every time they were called upon to act as intermediaries between the sovereigns or to hear their words before communicating them to M. Vissière. Just as the latter was about to leave with Dr Dethève, the empress called him back to ask him what the emperor's illness was, and, upon hearing his reply, she indicated her desire that adequate means might be found to cure the illustrious patient, and she expressed her thanks to the two Frenchmen for the trouble they had taken.

Dr Dethève and M. Vissière then backed out, making two deep bows, and, in the midst of the group of eunuchs who had partially invaded the room, they reached the courtyard with the princes.

Serge Franzini
'Le Docteur Dethève
et l'empereur Guangxu'
in *Études chinoises*, vol. XIV, no. 1,
spring 1995

My accession to the throne

Emperor Guangxu died in 1908, aged only thirty-six. He was succeeded by his nephew Puyi (reign title Xuantong), a child of two. In his autobiography, first published in 1964, Puyi writes of the memorable day on which he was enthroned as emperor of China.

Two days after I entered the palace Tzu Hsi [Cixi] died, and on 2 December [1908], the 'Great Ceremony of Enthronement' took place, a ceremony that I ruined with my crying.

The ceremony took place in the Hall of Supreme Harmony [Taihe dian]. Before it began I had to receive the obeisances of the commanders of the palace guard and ministers of the inner court in the Hall of Central Harmony

(Chungho tien) and the homage of the leading civilian and military officials. I found all this long and tiresome; it was moreover a very cold day, so when they carried me into the Hall of Supreme Harmony and put me on the high and enormous throne I could bear it no longer. My father, who was kneeling below the throne and supporting me, told me not to fidget, but I struggled and cried, 'I don't like it here. I want to go home. I don't like it here. I want to go home.' My father grew so desperate that he was pouring with sweat. As the officials went on kowtowing to me my cries grew louder and louder. My father tried to soothe me by saying, 'Don't cry; it'll soon be finished, it'll soon be finished.'

When the ceremony was over the officials asked each other surreptitiously, 'How could he say "It'll soon be finished? What does it mean, his saying he wanted to go home"?' All these discussions took place in a very gloomy atmosphere as if these words had been a bad omen. Some books said that these words were prophetic as within three years the Ching [Qing] dynasty was in fact 'finished' and the boy who wanted to 'go home' did go home, and claimed that the officials had a presentiment of this.

Puyi
From Emperor to Citizen,
trans. W. J. F. Jenner
1987

A tutor arrives in the Forbidden City

The British official, scholar and writer Reginald F. Johnston (1874–1938) served as tutor and moral advisor to the last emperor of China, Puyi, who continued to live in the Forbidden City for twelve years after the Chinese Republic was founded in 1912. On 3 March 1919

Johnston entered the Forbidden City, where he was to meet his young royal pupil.

The imposing Gate of Spiritual Valour through which I made my first entrance into the Forbidden City on 3 March 1919 led me into a new world of space and time. It was through that portal that I passed not only from a republic to a monarchy but also from the New China of the 20th century into a China that was old before the foundation of Rome. On the outer side of that gateway lay a million-peopled city throbbing with new hopes and new ideals – many of them, perhaps fortunately, never to be realized; a city that was striving to bring itself up to date and make itself worthy of its position as the capital of a great democracy; a city with a university thronged with eager students who in their reckless impatience were putting modern science and philosophy, together with Esperanto and the

Puyi and his tutor Reginald Johnston in the imperial gardens.

writings of Karl Marx, in the places lately occupied by the outworn sages of the Confucian tradition; a city in which cabinet ministers had been seen at presidential tea-parties in morning coats and top-hats; a city with a parliament that had yet to produce its Pitts and Gladstones but had already equipped itself with movable inkpots, and had hopes – also never to be realized – of some day possessing a duly-elected Speaker.

On the inner side of the same gateway were to be observed palanquins bearing stately mandarins with ruby and coral 'buttons' and peacocks' feathers on their official hats and white cranes and golden pheasants on the front of their long outer garments of silk; high court officials in loose-sleeved sable robes, with tufts of white fur (taken from the neck of the sable) as an indication that the wearer was one who had gained the favour of his sovereign; young nobles and court-chamberlains on horseback, their loose embroidered ceremonial gowns hiding both saddle and stirrups; eunuchs standing respectfully to attention, each attired in the uniform of his class; long-coated *sula* waiting in readiness to assist the great men out of their palanquins or to dismount from their ponies, and to conduct them to the waiting-rooms where they would be handed, with due ceremony, the indispensable cups of tea; officers of the household scrutinising the lists of those who were to be admitted to audience; and finally, in an inner room of the palace of the Nurture of the Mind, a boy of thirteen, slim of figure, gentle in manner and simply clad, the last occupant – perhaps – of the oldest throne in the world, the Son of Heaven, the 'Lord of Ten Thousand Years'. And indeed in those innermost palaces of the Forbidden City the Chinese republic might have been ten thousand miles away in space instead of only a few hundred yards, a thousand years away in time instead of contemporaneous.

The emperor was addressed as *huang shang* – the equivalent of 'imperial majesty'. The same term was also used by the members of the 'Inner Court' when speaking of the emperor in his absence, though among the tutors and high officers of the household an equally common expression was *shang-t'ou*, signifying 'he who is above' or 'the enthroned one'. The eunuchs more often used the expression *wan-sui-yeh* – 'the Lord of a myriad (or ten thousand) years', and this was also the term used by palace servants – eunuchs or *sula* – when sent to the houses of the tutors and other officers of the court, to convey imperial gifts or messages.

In the Forbidden City the lunar calendar was still observed, along with innumerable other customs and practices of Old China. More remarkable, perhaps, than the maintenance of the lunar calendar was the continued use of the emperor's reign title. Outside the Forbidden City, the year 1919 was the eighth year of the republic of China. But for all those who had the right to pass through the Gate of Spiritual Valour, the same year was the eleventh year of Hsüan-T'ung [Xuantong].

Reginald F. Johnston
Twilight in the Forbidden City
1934

The Last Emperor

In making The Last Emperor, *shot in 1986, the Italian film-director Bernardo Bertolucci (below, on the right) drew his inspiration from the autobiography published by Puyi, the last emperor of China. The film tells the remarkable story of the emperor who was to end his life as an employee of Beijing's botanical gardens.*

A diary kept during filming

Beijing, Saturday, 9 August 1986, studios

Yi! Er! San! The starting gun for the marathon goes off before dawn. Hairdressers, costumiers and propmen, make-up artists, actors and extras have been bustling frenetically for almost two hours while Bernardo takes possession of the scenery that will serve as the setting for the death of Tzu Hsi [Cixi]. Immediately, he gives directions regarding the overall action at the beginning of the scene. The doors swing open heavily. Puyi holds his father by the hand. We follow them both as they enter the room at the end of which, in the midst of cushions and clouds of incense, the old empress can barely be distinguished as she lies dying, surrounded by her court.

The task is a particularly arduous one for the electricians who have to operate over more than fifty metres [164 feet] to light the whole room, through tall lattice

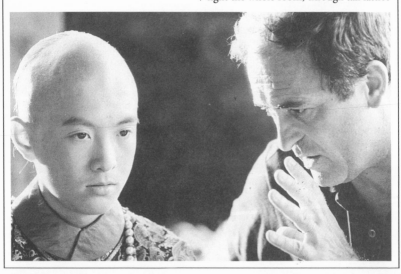

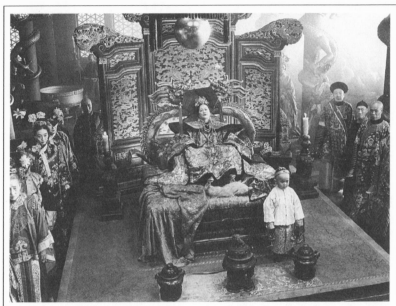

'We follow them both as they enter the room at the end of which, in the midst of cushions and clouds of incense, the old empress can barely be distinguished as she lies dying, surrounded by her court.'

windows modelled on those of the Pavilion of Imperial Supremacy. Due to the weight and bulk of the costumes, it soon became apparent that most of the actors, who were virtually incapable of movement, would have to be dressed on the set.

Unusually, the director has demanded a third camera.

Beijing, Monday, 11 August 1986, studios

Reverse shot of the entrance of Puyi and his father, while at the other end of Tzu Hsi's room, our thirty extras are patiently gathered together. Robertino dampens the floor in order to accentuate its shine, whilst *Bombardone* opens the tap of his smoke apparatus. After hurrying diagonally across the long

chamber, the small, intimidated child now walks past the hieratic figures of the dignitaries and courtiers. Astrologers, soothsayers and doctors follow him with their serious eyes. We are half-way between Goya and Otto Dix, between the wax museum and the horror film.

Beijing, Friday, 22 August 1986, Forbidden City

Threading his way among the throng of tourists, a tall black figure crowned by an opera hat elegantly makes his entrance on the platform to the unanimous applause of the crew. It is Reginald Johnston – R. J. to his friends – Puyi's new Scottish tutor, whose arrival in the walls of the Forbidden City, in 1919, is brought forward slightly in the

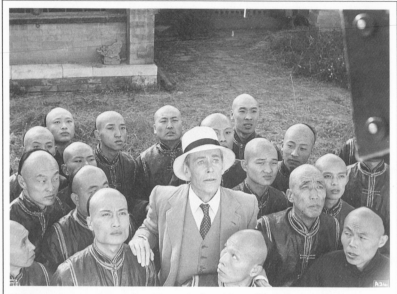

•What struck me most on my first visit was the faces. They still have an innocence that pre-dates the consumer society.•

work schedule for logistical reasons. Brando, Sean Connery and William Hurt were each approached in turn for the role. In the end, Peter O'Toole lends it his class, with his blond looks and his eyes the colour of a gushing stream.

Beijing, Saturday, 23 August 1986, Forbidden City

We find Puyi at the top of the watchtower where we left him on Thursday evening, at the very moment in which he discovers the existence of a new master of China. Whilst the Son of Heaven returns to earth again, the crowd of courtiers gathers gravely at his feet; the camera closes in on the walled-up portal that once again limits his horizons. The scaffolding is even slightly disproportionate in comparison to the works in progress, so that it is not entirely clear what kind of task the masons surrounding the little emperor are engrossed in, but the expedient provides the perfect illusion. After all, this is the cinema.

Fabien S. Gérard
Ombres jaunes, Journal de tournage, 'Le Dernier Empereur' de Bernardo Bertolucci
1987

The emperor and the director: an interview with Bertolucci

When did you first become interested in China and its last emperor?

Someone who loved China, who cherished the idea of taking me to China, and who, above all, dreamt of making a great film about China,

introduced me, in an extremely subtle way, to the two yellow volumes of Asion Giro Puyi's autobiography, *From Emperor to Citizen*. The account is based on the notebooks Puyi wrote during the period in which he was imprisoned by the Communists, between 1950 and 1959. They were reworked by a ghost writer, a journalist called Lih-Ven-Da, who is now a great friend and a consultant on the script. Later, the book was revised and edited by Lao She, one of the most popular writers of the post-war years, who committed suicide during the Cultural Revolution, a Manchurian like Puyi. I kept this book for a long time before reading it. Then, towards the end of 1983, I began to flick through it. It was at the time when, yet again, I had lost all hope of making *Red Harvest*. I had some reservations, I vaguely knew, rather like a moral fable, the story of this emperor who, at the end of his life, became a gardener in the botanical gardens in Beijing. I have always been fascinated by China, but, after reading Puyi's autobiography, I felt reluctant to make a film on such a specialist subject. I said to myself: this is a world that is not for me.

How did you choose the actors?

What struck me most on my first visit was the faces. They still have an innocence that pre-dates the consumer society, an innocence that does not mean a lack of sophistication or of very ancient vices. Four thousand years of culture have provided them with great elegance and diplomacy in the way in which they express themselves and behave. But they have not yet reached the stage of being invaded by MacDonalds and by 'Coca-colonization'. It is in this that their true innocence lies. I would like the faces of the crowd in the film to be chosen precisely on this basis. Given that the film will be in English, there will be a problem for the actors. For one of the many negative aspects of the Cultural Revolution is that very few people speak English.

How do you view the Forbidden City....
Is it just an air bubble completely outside history?

I have been to Cogoon [the Forbidden City] many times to try to understand, in that world of yellow tiles – the famous imperial yellow, which is very similar to Parma yellow, I subsequently realized – the key to its system of aesthetics. The city was built around 1400 and everything that is visible today dates more or less from that period. Nevertheless, history does not record the name of a single architect, a single sculptor.

Does the reception the Chinese give to the film matter more to you than the reaction of the rest of the world?...

I am very conscious of making a film with the total approval of the Chinese, but from a Western point of view. Inevitably, the need to condense, to which I have just alluded, carries huge risks, including the possibility of committing terrible blunders. The objective I have set myself is to get to know the country as well as possible, its history, its psychological, cultural, historical patterns, so as to be able, if I have to be unfaithful, to be so consciously and not through ignorance. China has a potential public of a billion people. It's better not to think about it, I would be petrified.

Bertolucci par Bertolucci,
Entretiens avec Enzo Ungari et
Donald Ranvaud, 1987

Writers' memories

From the 1930s to the present day, many writers have visited the Forbidden City. All of them in their own way have expressed the fascination exerted by the former residence of the Sons of Heaven.

A bove and opposite: carved pillar and throne with 'gigantic bronze incense burners' in the Hall of Supreme Harmony.

A splendid deserted hive

The English writer and traveller Peter Quennell journeyed to Beijing in the early 1930s. The Forbidden City had been badly neglected in the years since the departure of the imperial family. With his eye for detail and vivid powers of description, he chronicles the fall from grace.

An awful vacuum seemed to exist through the whole palace. Latticed casements, in the pavilions and under the cloisters, showed black holes where the paper panes were torn. Peering in, one saw dirt and piles of rubbish. The sagging doors were roughly stamped by an official seal.

Utter emptiness as in a splendid deserted hive: and the sense of squalor which always accompanies such desertion. Something in the atmosphere of a palace or temple starts to putrefy when the human occupants vanish. And they had all gone; a lounging soldier at the gate, who wore the badge of the Nationalist government in Nanking, watched the foreign intruders with vague insolence. A spectacled person sold tickets from a box; an aged dwarf came toddling up to tear the counter-foils…. *Sic transit.* The tag slips out so easily; there was a time when the past glories of the world went up in smoke at the touch of change. Nowadays we are more conservative of fallen splendour and empty palaces, from Peking to Madrid, are handed over to a dim rabble of custodians who punch tickets, jingle coins and erect notice boards.

Peter Quennell
A Superficial Journey through Tokyo and Peking
1932

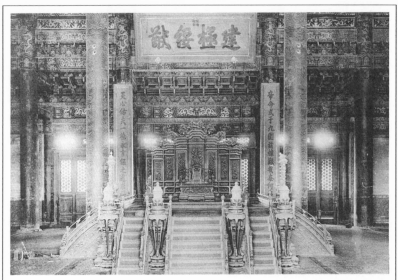

'My eyes have seen the wonder today'

During a sleepless night after a visit to the Forbidden City in 1935, the Greek writer Nikos Kazantzakis (1885–1957) noted down his impressions of the palace.

As the fakir's eye forces the seed to sprout, to flower, to bear fruit and to rot away, so today on the snow-white marble threshing floor I saw the beginning and the end of an unexpected human victory. And I still hold the vision within my eyelids and I do not want to sleep and lose it: the acacias had blossomed, Peking buzzed like a beehive full of yellow bees, the castle gate of the Forbidden City was wide open, and in vain the two bull heads with gilded wild horns tried to chase away the evil spirits and not let them step into sacred space. A few years ago, as soon as the imperial court had been dissolved like morning dew, the locks had broken, and the evil spirits, the 'white demons', had gone back and forth freely in the deserted palaces and the imperial courts.

The little carriage, the ricksha, stopped at the entrance and I stepped down. Vast, mythical, this wonder extended in front of me: wide marble steps, short, fat, laughing bronze lions with heavy bells on their chests like court jesters, all-gold fairytale palaces whose kings have become grass, moving lightly on the rooftops. High gates falling apart and marked with three old established words in golden cheerful letters: *Tai-chu-men* ('Large happy gate'). Gigantic bronze incense burners like cauldrons. They are now deserted, without burning coal, without fragrant smoke. In one of these burners I saw a yellow wasp with black stripes weaving the empty cells of her hive. Bronze long-legged storks with high necks; and marble turtles; and next to the winged imperial dragon was the mythical bird with the long wings, the phoenix, the *feng*, the bird that symbolized the

empress. Inside the bronze bird they used to put scents and when the emperor passed by they set them on fire....

The palace where once the harem of the emperor buzzed now shines, surrounded by high, blood-red walls. Hieroglyphic letters appear on the walls like skeletons, like human ribs, like lacerated hands and feet. The rooms are deserted, the walls are peeling and crumbling, the roofs crack, and the yellow, green and blue varnished tiles are breaking loose in fragments. Many large halls have become museums where precious remains of the great treasures are piled up – paintings on silk, earrings, bronze bracelets, fans and small ladies' pillows of porcelain. And on the porcelain are painted weeping women under willow trees. On the shelves are vases with exquisite forms, like breasts, like loins, like necks of women. Tarnished silver mirrors, mortars for cosmetics, green necklaces, a multitude of candles that on a tragic night were extinguished for ever.... I gather wild flowers and camomiles that sprout on the marble steps. I hear my steps echoing in the deserted rooms of the palace and a superhuman joy buds in my mind. I remember the spring on the island of Crete in the plain of Messara; it is an awesome spectacle; early in the morning, before the sun rises over the plain, sometimes you see high on the dimly lit horizon huge shadows, like an army hastily marching in straight lines. The sun comes out and the armies disappear. The Cretans call these men who are created and disappear with the dew *drosoulites* ('dewlets'). Like them, the Chinese kings passed from the earth and vanished.

Nikos Kazantzakis
Travels in China and Japan
trans. George C. Pappageotes, 1964

A palace that 'speaks in the moving language of ruins'

Simone de Beauvoir (1908–86) was only able to appreciate the architecture of the Forbidden City at the end of her visit by wandering off the beaten track.

On the other side of the vaulted tunnel you find yourself in the outer courtyard of the Imperial Palace – it is thus the Chinese refer to it today, denying it that fine title, 'The Forbidden City', which used to inspire dreamy thoughts in Western visitors. The Chinese are right; if the idea of a forbidden city intrigues, beckons, it is because of a contradiction in terms: a city into which the population is not admitted has obviously usurped the title of a city. It was nothing but their pride that enabled the old emperors to suppose that their presence in the place they inhabited raised it to the rank of a city; as a matter of fact, their city was never anything beyond a palace. To it they gave yet another gorgeous name: The Violet-Purple City. Here too disappointment awaits the over-credulous traveller. The enclosing walls and the inside walls are of a somewhat drab red bordering on the colour of brick. Actually, the 'violet-purple' epithet designated not a visible hue but a symbolic one. Violet purple is emblematic of the North Star where lies that supreme celestial palace whereof the imperial residence claimed to be the terrestrial counterpart: the absolute centre of this world as the polar star is the pivot round which turns the world above....

I concede that one may have a taste for the rudimentary and at the same time refined elegance of this architecture and for the harmonies that can be achieved through the use of mineral

colours. For my part, though, a stucco-and-wood palace will never be as handsome as a house of stone. Stone resists the ravages of time while reacting to it. Its history does not by-pass it but becomes a part of it, stays part of it. These other materials crumble, their colours shine but they do not take on any patina; new or old they always seem to belong to a certain undefined period. The Imperial Palace does not have a restored look, nor has it an ancient one: this hesitation makes it appear not eternal but precarious and like an imitation of itself.

It affects me more strongly if instead of the buildings I turn my attention to the spaces they delimit: courtyards, terraces, stairways. As in certain modern private houses and developments an ambivalence between the ideas of outside and inside is reflected here; this porch was only meant to be a thoroughfare, that court was a ballroom where people stood for hours on end. One must not, therefore, consider this parvis, these tiered gardens as mere devices for setting edifices in perspective; they constitute architectural objects in themselves; their proportions, their dimensions, symmetry subtly played against asymmetry, the solemn quality of the stairways, the balustrades' gracefulness compel admiration. Here, I feel, is where the imperial architects won their outstanding success: in imparting this movement to space, where, with stately, gradual rhythms, pauses and ascents are ordered with the sure mastery that also prescribes oblique promenades in the maze of lateral alleys and sequestered walks.

All the same, this beauty strikes me as chill, and I know why. There is nothing accidental about the impermanence of the materials; it is simultaneously the cause, the effect, the expression of a troubling fact: the traces left upon this palace by the past are so few that, paradoxically, I would hesitate to call it a historical monument; it was, like Peking, begun anew by each dynasty: it preserves the mark of none of them…. Here, nothing conjures up Kublai [Kubilai Khan], Yung Lo [Yongle] or Ch'ien Lung [Qianlong]. One has the feeling this inner city never really belonged to them, that they never belonged to it – in all likelihood because they never belonged to themselves. Between the encroachments of their private debauches and the sacred character of their public office, they were too hemmed in to affirm their personalities; those who may have possessed such a thing frittered it away in this enclave, estranged from their mandate and seeking oblivion in pleasure; that is why the hot-blooded barbarian conquerors found Peking so boring. The only shade lingering still in the phoenix-and-dragon-adorned apartments is that of 'the Old Buddha', the Empress Tzu Hsi [Cixi], and she scarcely fires one's imagination. This palace, in which not one dated memory is inscribed, strikes me as the unalterable seat of an unalterable institution and not the dwelling place of men who were one time alive….

Jean-Paul Sartre and Simone de Beauvoir in Beijing in 1955.

The barriers have tumbled. The Forbidden City has become a public place; now everyone strolls freely through its courtyards, sips tea under its porches; Young Pioneers in red neckerchiefs visit the exhibits mounted in its hallways; certain buildings have been turned into palaces of culture, into libraries; in another part of it the government has its seat. Beneath this new life invading it the original meaning of the palace remains unimpaired; I seldom succeeded in forgetting it. But there was one time when, wandering at random, with nothing of old history or myths in my heads, I fell in love with some abandoned secondary courtyards gone to weeds or else planted with little dark trees, infinitely deserted and solitary. In one corner dandelions would be growing; the reddish wall capped by gilt tiles and running along an ill-paved court made me think of farms I have seen in Burgundy. Bucolic, divested of all purpose, this too frequently restored palace speaks in the moving language of ruins.

Simone de Beauvoir, *The Long March*
trans. Austryn Wainhouse, 1958

Malaparte visits the Forbidden City with his interpreter

In his posthumous notebooks, the Italian writer Curzio Malaparte (1898–1957) has left an enthusiastic description of the imperial palace. He was nevertheless unable to refrain from calculating its cost on the Chinese people.

Later, we went to visit the Forbidden City, the Imperial City, and I wandered along behind Hong Sing through those marvellous courtyards, through those palaces all set apart from each other, and I felt giddy, for there is nothing in the world, and I mean nothing, not even Versailles, which evokes such a sense of majesty, of earthly power, of wealth, of pomp, as the imperial palaces of Beijing.

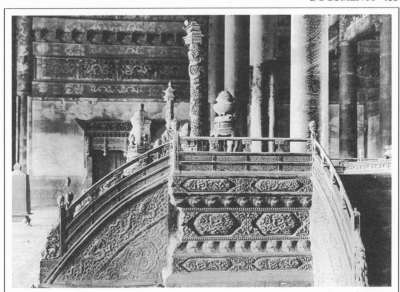

Above: the imperial dragon. Opposite: 'the Forbidden City has become a public place'.

Readers, do not expect anything from my description of the Imperial City: many have attempted to describe it, no one has succeeded. As for myself, I am neither foolish nor presumptuous enough to imagine that I could describe something so remarkable and so unbelievable. I shall only say that my head was spinning, that I was dazzled by those solid walls, so high, by the immense courtyards, by the dragons, the lions, the palaces with golden roofs, the columns of vermilion lacquer, the green, red and yellow facing.

'The emperor slept here, the empress slept here, this was the apartment of the favourite, those the apartments of the concubines', said Hong Sing. And I looked at the huge Ming porcelain vases, the carved jades, the carved ivory, the gilded bronze tripods, the necklaces of turquoise stones (and when I say stones, I mean stones, weighing up to eighty grammes), the furniture inlaid with gold and silver, the golden bowls, and I felt giddy, and I, too, experienced the same feelings as the crowd of visitors, all labourers, students and soldiers who, at all hours of the day, filled the Forbidden City: a feeling of revulsion at the thought that these riches, this splendour, this extravagance had for centuries and centuries been counterbalanced by the terrible poverty of the Chinese people: the hundreds of millions of peasants who worked and lived, while starving, to allow this unbelievable luxury and extravagance, and it mattered little to me that the luxury and extravagance had been remarkable, for an organized population, a people's well-being, is also a remarkable thing.

Curzio Malaparte
Viaggio in Russia e in Cina, 1958

Following the guide

The Forbidden City has now become a major tourist attraction. Should this be condemned or should the astonishing durability of this palace that has managed to survive the vicissitudes of history be admired?

Off-limits in the Forbidden City

Princess Der Ling, the daughter of a Manchu nobleman, became first lady-in-waiting to the Empress Dowager Cixi in 1903. She thus had ample opportunity to study the woman who ruled China and the Forbidden City for so long. Here she describes the discovery of some mysterious buildings in the very heart of the city itself.

Things went very slowly during this eleventh moon on account of the Court being in mourning, so one day Her Majesty suggested that she should show us round the Forbidden City. First we proceeded to the Audience Hall. This differs somewhat from the Audience Hall of the Summer Palace. To enter, one must mount some twenty odd steps of white marble, with rails on either side of the steps made of the same material. At the top of the steps a large veranda, supported by huge pillars of wood, painted red, surrounded the building. The windows along this veranda were of marvellously carved trellis-work, designed to represent the character 'Shou' arranged in different positions. Then we entered the hall itself. The floor is of brick, and Her Majesty told us that all these bricks were of solid gold and had been there for centuries. They were of a peculiar black colour, doubtless painted over, and were so slippery that it was most difficult to keep on one's feet. The furnishing was similar to that in the Audience Halls in the Summer Palace and the Sea Palace, with the exception that the throne was made of dark brown wood inlaid with jade of different colours.

The hall was only used for audience on very rare occasions, such as the birthday of the empress dowager and New Year's Day, and no foreigner has

ever entered this building. All the usual audiences were held in a smaller building in the Forbidden City.

After spending some little time in the Audience Hall, we next visited the emperor's quarters. These were much smaller than those occupied by Her Majesty, but were very elaborately furnished. There were thirty-two rooms, many of which were never used, but all were furnished in the same expensive style. In the rear of this building was the Palace of the Young Empress, which was smaller still, having about twenty-four rooms in all, and in the same building three rooms were set apart for the use of the secondary wife of the emperor. Although close together, the palaces of the emperor and his wife were not connected by any entrance, but both buildings were surrounded by verandas connecting with Her Majesty's apartments, which were quite a distance away. There were several other buildings, which were used as waiting rooms for visitors. In addition to the above, there were several buildings which were not used at all; these were sealed and nobody seemed to know what they contained, or whether they contained anything at all. Even Her Majesty said she had never been inside these buildings, as they had been sealed for many years. Even the entrance to the enclosure containing these buildings was always closed, and this was the only occasion that any of us ever passed through. They were quite different in appearance from any other buildings in the palace, being very dirty and evidently of great age. We were commanded not to talk about the place at all.

Princess Der Ling
Two Years in the Forbidden City
1924

'A physical feeling of happiness'

The writer and Sinologist Pierre Ryckmans (pseudonym Simon Leys) was well acquainted with the Forbidden City. Here he praises its harmony and equilibrium.

The Forbidden City has miraculously been preserved (is it because Mao Tse-tung [Mao Zedong] likes now and again to play at being emperor from the balcony of T'ien-an men [Tianan men]?). Whatever the reason, this vast gathering of courts and palaces remains one of the most sublime architectural creations in the world. In the history of architecture, most monuments that try to express imperial majesty abandon the human scale and cannot reach their objective without reducing their occupants to ants. Here, on the contrary, greatness always keeps an easy measure, a natural scale; it is conveyed not by a disproportion between the monument and the onlooker but by an infallibly harmonious space. The just nobility of these courts and roofs, endlessly reaffirmed under the changing light of different days and seasons, gives the onlooker that *physical* feeling of happiness which only music can sometimes convey. As a body loses weight in water, the visitor feels a lightening of his being to swim thus in such perfection – in curious contra-diction to the explanatory notices that the authorities have put at the entrances to each court building, describing the Chinese imperial regime in terms which would best evoke the dark and cruel horror of some Assyrian tyranny, and which would hardly account for this quality of equilibrium that seems to have inspired the whole city.

Simon Leys, *Chinese Shadows*, 1978

FURTHER READING

Anderson, Aeneas, *A Narrative of the British Embassy in China*, 1796

Backhouse, E., and J. O. P. Bland, *Annals and Memoirs of the Court of Peking*, 1914

Blunden, Caroline, and Mark Elvin, *Cultural Atlas of China*, 1983

Cameron, Nigel, *Barbarians and Mandarins: Thirteen Centuries of Western Travellers in China*, 1989

Dan Shi, *Mémoires d'un eunuque dans la Cité interdite*, 1991

Er Si and Shang Hongkui, *Inside Stories of the Forbidden City*, trans. Zhao Shuhan, 1986

Hearn, Maxwell K. Hearn, *Splendors of Imperial China: Treasures from the National Palace Museum, Taipei*, 1996

He Li, *Chinese Ceramics*, 1996

Holdsworth, May, and Caroline Courthauld, *The Forbidden City*, 1995

Hook, Brian (ed.), *The Cambridge Encyclopaedia of China*, 1991

Jin Yi, *Mémoires d'une dame de la cour dans la Cité interdite*, 1993

Johnston, Reginald F., *Twilight in the Forbidden City*, 1934

La Cité interdite. Vie publique et privée des empereurs de Chine (1644–1911), 1996

Leys, Simon, *Chinese Shadows*, 1978

McGhee, Rev. R. J. L., *How We Got to Pekin: A Narrative of the Campaign in China of 1860*, 1862

Puyi, *From Emperor to Citizen*, trans. W. J. F. Jenner, 1987

Rawson, Jessica, (ed.), *The British Museum Book of Chinese Art*, 1992

Tregear, Mary, *Chinese Art*, 1997

Wan Yi, Wang Shuqing and Lu Yanzhen, *Daily Life in the Forbidden City*, 1988

CHRONOLOGY OF THE MING AND QING DYNASTIES

Ming dynasty (1368–1644)		
1368–1398	Hongwu	
1399–1402	Jianwen	
1403–1424	Yongle	
1425	Hongxi	
1426–1435	Xuande	
1436–1449	Zhengtong	
1450–1456	Jingtai	
1457–1464	Tianshun	
1465–1487	Chenghua	
1488–1505	Hongzhi	
1506–1521	Zhengde	
1522–1566	Jiajing	
1567–1572	Longqing	
1573–1620	Wanli	
1620	Taichang	

1621–1627	Tianqi	
1628–1644	Chongzhen	
Qing dynasty (1644–1912)		
1644–1661	Shunzhi	
1662–1722	Kangxi	
1723–1735	Yongzheng	
1736–1795	Qianlong	
1796–1820	Jiaqing	
1821–1850	Daoguang	
1851–1861	Xianfeng	
1862–1874	Tongzhi	
1875–1908	Guangxu	
1909–1912	Xuantong	

LIST OF ILLUSTRATIONS

The following abbreviations have been used: *a* above; *b* below; *c* centre; *l* left; *r* right.

COVER

Front, background Xu Yang. *View of the Capital* (Beijing). Scroll dated 1770. Imperial Palace Museum, Beijing

Front b The Imperial Palace, Beijing. Photograph by Joan Lebold Cohen

Spine Unknown artist. *Concubine of the Emperor Yongzheng*. Imperial Palace Museum, Beijing

Back Procession in front of the Hall of Supreme Harmony. Detail from the scroll *The Wedding of Emperor Guangxu*. Imperial Palace Museum, Beijing

MAP 137

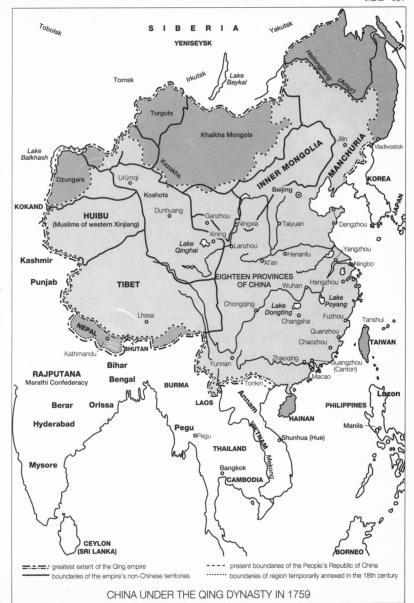

Tobolsk

S I B E R I A Yakutsk

YENISEYSK

Tomsk Irkutsk *Lake Baykal*

Heilongjiang (Amur)

Lake Balkhash

Torguts

Khalkha Mongols

Kazakhs

Jilin

INNER MONGOLIA

MANCHURIA

Vladivostok

Dzungars Urümqi

Koshots

Beijing ⊙

KOREA

KOKAND

HUIBU (Muslims of western Xinjiang) Dunhuang

Ganzhou

Ningxia

Taiyuan

Dengzhou

JAPAN

Xining

Lanzhou

Henanfu

Yangzhou

Ningbo

Kashmir

Lake Qinghai

Xi'an

Punjab

TIBET

EIGHTEEN PROVINCES OF CHINA

Wuhan

Hangzhou

Lhasa

Chongqing

Lake Dongting

Lake Poyang

Fuzhou

Tanshui

NEPAL

Changsha

Quanzhou

TAIWAN

BHUTAN

Chaozhou

Kathmandu

Bihar

Yunnan

Zhaoqing

Guangzhou (Canton)

RAJPUTANA Marathi Confederacy

Bengal

BURMA

Tonkin

Macao

Berar

Orissa

LAOS

Annam

PHILIPPINES

Luzon

Hyderabad

Pegu

oPegu

VIETNAM

Mekong

HAINAN

Manila

Mysore

THAILAND

Shunhua (Hue)

Bangkok

CAMBODIA

CEYLON (SRI LANKA)

BORNEO

=·=·=· greatest extent of the Qing empire

– – – present boundaries of the People's Republic of China

—— boundaries of the empire's non-Chinese territories

·········· boundaries of region temporarily annexed in the 18th century

CHINA UNDER THE QING DYNASTY IN 1759

CHAPTER 3

CHAPTER 4

INDEX

ACKNOWLEDGMENTS

The publishers wish to thank Éditions Findakly, Gilles Huot, Nathalie Frémeau and Hélène Chollet of the Musée Cernuschi.

PHOTO CREDITS

AKG 108. All rights reserved 14–5, 20–1, 26a, 39, 98, 137, 141. Gallimard archives 88–9, 89a, 91, 100, 105, 110, 111, 119. Cahiers du Cinéma Collection 124, 125, 126. Joan Lebold Cohen front cover b. Documentation Tallandier 86, 86–7, 131. Suzanne Held 13, 16–7b, 18, 42, 45, 46, 54–5, 64b, 76, 95, 104, 132, 134. Hoa-Qui/C/R Jaffre 44. Hoa-Qui/Philippe Wang 97. Imperial Palace Museum, Beijing front cover background, spine, back cover, 11, 16–7a, 19, 22–3, 24–5, 26–7a, 26–7b, 28, 29, 30–1a, 30–1b, 32, 33l, 33r, 34r, 36–7, 40–1, 42–3a, 42–3b, 44–5, 47a, 48, 49, 52–3, 54, 55, 56, 58–9a, 58–9b, 59, 60–1, 61a, 61b, 62al, 62ar, 64a, 65, 66, 66–7, 67, 69, 70, 70–1, 72, 73, 74, 75, 76–7, 78a, 78b, 78–9, 80, 81a, 81b, 82a, 82b, 82–3, 84, 87, 89b, 90, 92–3, 93a, 122. Roland and Sabrina Michaud 15, 20, 21a, 21b, 47b, 50, 51a, 116–7. National Palace Museum, Taipei 12, 71. Paris-Musées/Christophe Walter 118–9, 128, 129, 133. Private collection 114. Rapho/Paolo Koch 51b, 68. Marc Riboud 1–9. RMN 37, 38, 63a. Roger-Viollet 34l, 35, 90–1, 93b, 106; Boyer 94–5; Harlingue 121. Sygma/G. Ranciman 85, 96. Victoria and Albert Museum, London 57, 62b, 63b.

TEXT CREDITS

Grateful acknowledgment is made for use of material from the following works: (pp. 130–2) Simone de Beauvoir, *The Long March*, translated by Austryn Wainhouse, 1958, © Gallimard 1957; reprinted by permission of Editions Gallimard. (pp. inside front cover, *95*, 122–3) Reginald F. Johnston, *Twilight in the Forbidden City*, Victor Gollancz, 1934; reprinted by permission of Victor Gollancz Ltd. (pp. 129–30) Nikos Kazantzakis, *Travels in China and Japan*, translated by George C. Pappageotes, 1964; reprinted by permission of Patroclos Stavrou. (pp. 98–9) *The Travels of Marco Polo*, ed. Manuel Komroff, 1928; reprinted by permission of the Peters Fraser & Dunlop Group Ltd. (pp. 114–5) Victor Segalen, 'Violet Forbidden City', *Steles*, translated by Andrew Harvey and Iain Watson, 1990, © 1990 Andrew Harvey and Iain Watson; reprinted with the permission of Aitken & Stone Ltd.

Gilles Béguin
is director of the Musée Cernuschi and head
curator of the collection. Author of numerous
scientific and academic articles, he has organized
many exhibitions including 'The Forbidden City'
(1996) at the Petit Palais, Paris.
He is the author of the main text in this book.

Dominique Morel
is a curator at the Musées de la Ville de Paris.
Drawing on his studies both in literature and the
history of art, he has organized many exhibitions
devoted to the artistic and literary world of the
19th century. Since 1988 he has been head of the
department of objects of art at the Petit Palais
and regularly publishes articles in various reviews. He
has compiled the Documents section of this book.

Translated from the French by Ruth Taylor

For Harry N. Abrams, Inc.
Editor: Eve Sinaiko
Cover designer: Dana Sloan

Library of Congress Cataloging-in-Publication Data

Béguin, Gilles.
 [La cité interdite des fils du ciel. English]
 The Forbidden City : center of imperial China / Gilles Béguin and
Dominique Morel.
 p. cm. — (Discoveries series)
 Includes bibliographical references and index.
 ISBN 0–8109–2822–1 (pbk.)
 1. Forbidden City (Peking, China)—History. 2. China—History.
I. Morel, Dominique. II. Title. III. Series: Discoveries (New York,
N.Y.)
DS795.8.F67844 1997
951'.156—dc21 97–21846

Printed and bound in Italy by Editoriale Libraria, Trieste